Bay of Fundy

A Natural Portrait

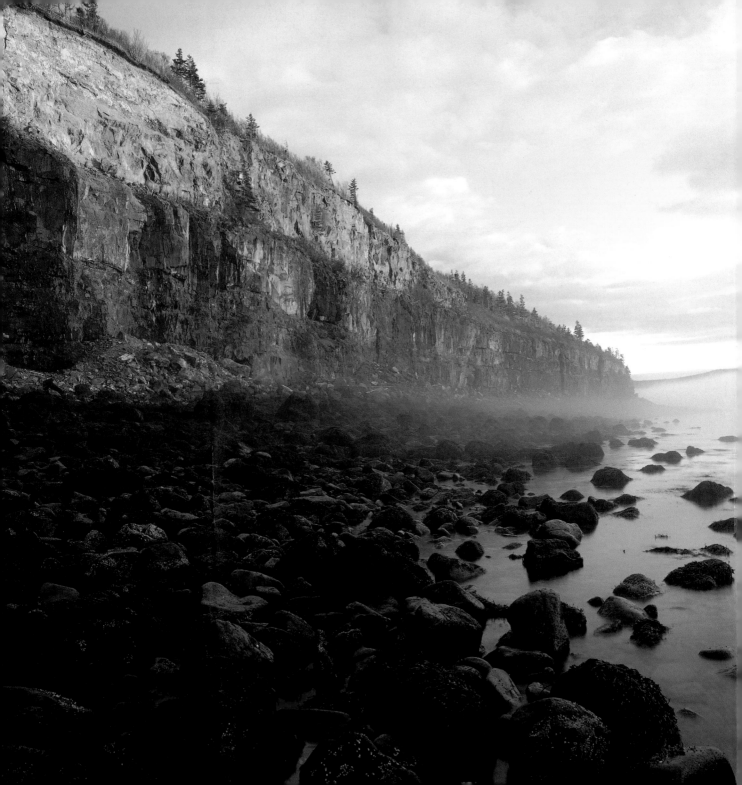

Bay of Fundy
A Natural Portrait

TEXT AND PHOTOGRAPHS BY

Scott Leslie

KEY PORTER BOOKS

For Lloyd "Jack" Leslie

Library and Archives Canada Cataloguing in Publication

Leslie, Scott, 1963-
 Bay of Fundy : a natural portrait / Scott Leslie.

ISBN 978-1-55263-856-9

 1. Natural history--Fundy, Bay of--Pictorial works. 2. Fundy, Bay of--Pictorial works. I. Title.

QH106.2.F85L44 2007 508.3163'45 C2006-906412-1

THE CANADA COUNCIL | LE CONSEIL DES ARTS
FOR THE ARTS | DU CANADA
SINCE 1957 | DEPUIS 1957

ONTARIO ARTS COUNCIL
CONSEIL DES ARTS DE L'ONTARIO

The publisher gratefully acknowledges the support of the Canada Council for the Arts and the Ontario Arts Council for its publishing program. We acknowledge the support of the Government of Ontario through the Ontario Media Development Corporation's Ontario Book Initiative.

We acknowledge the financial support of the Government of Canada through the Book Publishing Industry Development Program (BPIDP) for our publishing activities.

Key Porter Books Limited
Six Adelaide Street East, Tenth Floor
Toronto, Ontario
Canada M5C 1H6

www.keyporter.com

Text design and electronic formatting: Martin Gould

Printed and bound in Canada

07 08 09 10 11 5 4 3 2 1

Table of Contents

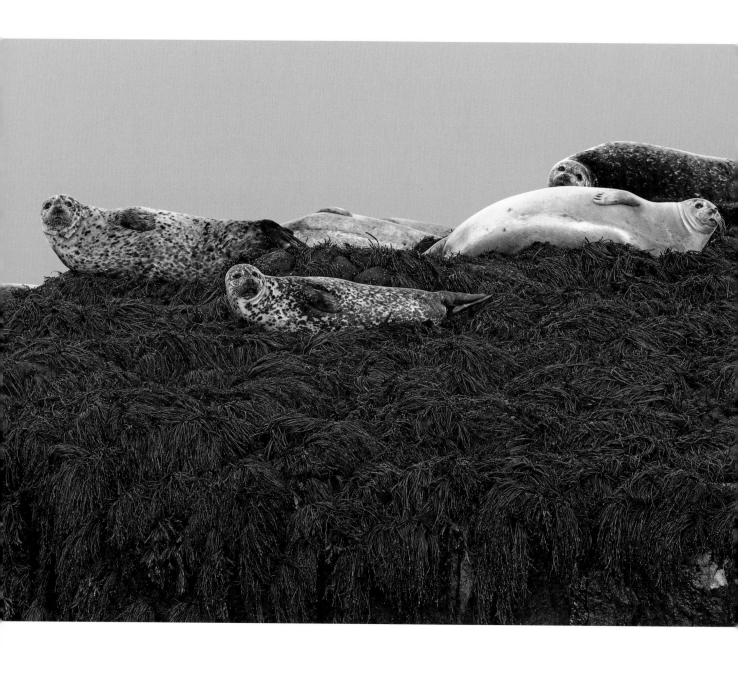

Bay of Fundy

A Natural Portrait

Preface

AT ROUGHLY 12,000 SQUARE KILOMETRES IN AREA, the Bay of Fundy is just a small fraction of the 82 million square kilometres that comprise the Atlantic Ocean. Yet its biological diversity and productivity make it one of the most prodigious cold-water Atlantic ecosystems. So far, about 2,400 species have been documented for the Bay of Fundy, substantially more than what was previously thought. Two main factors contribute to this natural wealth. The bay lies at an area of overlap of Arctic and temperate ecozones, so it hosts species from both. And there are the famous Bay of Fundy tides, the greatest on Earth. Twice a day, the great oceanic heartbeat of the tide pulses in and out of the bay. An astonishing 200 billion tonnes of water enter and exit on a single cycle, greater than the combined

flow of all the rivers on Earth. This enormous daily influx of well-mixed, oxygenated, plankton-filled water provides a continuous food supply for creatures from the minute to the magnificent.

Hundreds of species of fish and birds live here, and thirty kinds of mammals, including one of the rarest whales in the world, the northern right whale. There's more to the bay's story than marine wildlife and tides, however. Millions of hungry shorebirds visit its vast mud flats every fall during their southward migration. Thousands of hectares of verdant salt marshes blanket the shores of the uppermost bay. Its coastline is immensely beautiful; its geological history fascinating. In many places it is still wild and untouched. Millions of years ago, reptiles and dinosaurs roamed here, leaving fossils that tell yesterday's story of life even as the grand pageant of evolution continues in today's Bay of Fundy.

Introduction

IT IS A TESTAMENT TO THE ENORMITY OF THE SEA that a 40-tonne right whale can disappear in it like a frog in a pond. It's late August and we are standing on the deck of a lobster boat in the middle of the Bay of Fundy, scanning the smooth water for any sign of the whale's return. After several minutes the elusive animal surfaces in a fizz of white water about 200 metres off the starboard side. In wetsuits and snorkelling gear, my dive partner and I slip quietly over the gunwale of the boat, my underwater camera tightly in hand.

Deep water and abundant food make this area a

An endangered Bay of Fundy northern right whale, one of the rarest marine mammal species on Earth.

favourite for the rare North Atlantic right whale during the summer. We have come across the bay from the Nova Scotia side to an area known as the Grand Manan Basin to photograph one of the most endangered species on Earth.

Once we are in the water the boat steams about a half kilometre away, leaving us floating over an abyss of emerald green water that's full of the plankton that right whales love to eat. The whale is resting on the surface some distance away, so all we can do is wait. There's little point trying to approach it; besides being illegal for a swimmer or diver to actively pursue a whale, it would only swim away. Our only hope for a close encounter is that the whale's innate sense of curiosity will bring him to us. We wait patiently for almost an hour in our buoyant wetsuits, growing colder by the minute. Our hopes dashed, we decide we've had enough. Just as I begin to lift my arm to signal the boat to pick us up, my companion exclaims, "Whoa! He's right here. I think he's coming our way!" I spin around and see the massive animal swimming straight for us on the surface, a bow wave breaking over its blunt nose. About 50 metres away it quietly submerges. Breathlessly, we await its arrival.

Submerging my mask in the water, I first make out large light patches called callosities, followed by the dark grey bulk of the animal emerging from the green murk

about 10 metres away. Streaming sunlight illuminates its back as it swims directly beneath us. My companion and I take a few deep breaths, hold the last one in, and dive down to meet the whale, now rolled on its side and looking up at us. Its grapefruit-sized eye follows us as we swim alongside. Just metres apart, humans and whale briefly acknowledge each another, a rare encounter bridging the 60 million years of evolution that separate us. We float in mid-water, two stick figures dwarfed by the whale's enormity. For a long moment it doesn't move. I shoot a few pictures. Then it begins to swim. We turn and see its huge flipper coming straight for us. Before we have a chance to get out of the way, the whale gingerly folds the 3-metre-long appendage against its body to avoid contact. Then the tail slips by and the whale is gone. With our lungs burning we make a dash for the surface. The sea air never tasted so sweet!

For thousands of years we have held whales in awe. Their huge bodies are so overwhelming, their deep blue home so unfathomable (both physically and psychologically), their ocean language so indecipherable, their intelligence so indisputable. They are one of the mysteries of the seas.

But whales are just one important part of this amazing ocean wilderness wedged between New Brunswick and

Nova Scotia. The menagerie of life on its sea floor; the prodigious biological wealth of its undersea forests; the strange inhabitants floating like inner-space voyageurs through its emerald-green water; the millions of migratory birds that depend on its bounty. This is the Bay of Fundy. Few places on Earth can boast so much natural wealth in so small an area. In the following pages are glimpses of these riches.

Although it looks somewhat sponge-like, this sea peach tunicate actually belongs to a much higher phylum of animals because during one of its early life stages it possesses a primitive spinal column known as a notochord. In fact, it belongs in the phylum Chordata with fish, mammals, and birds.

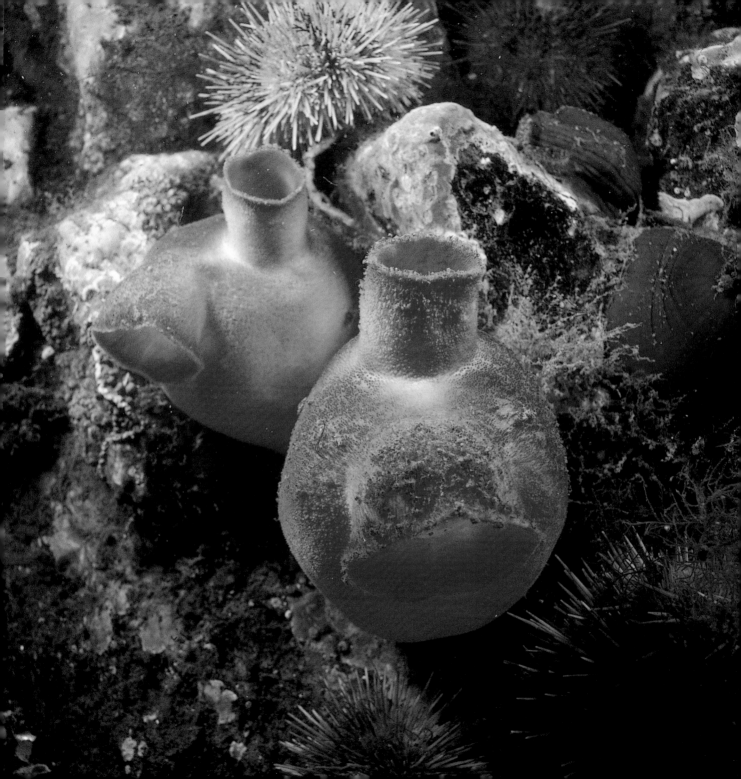

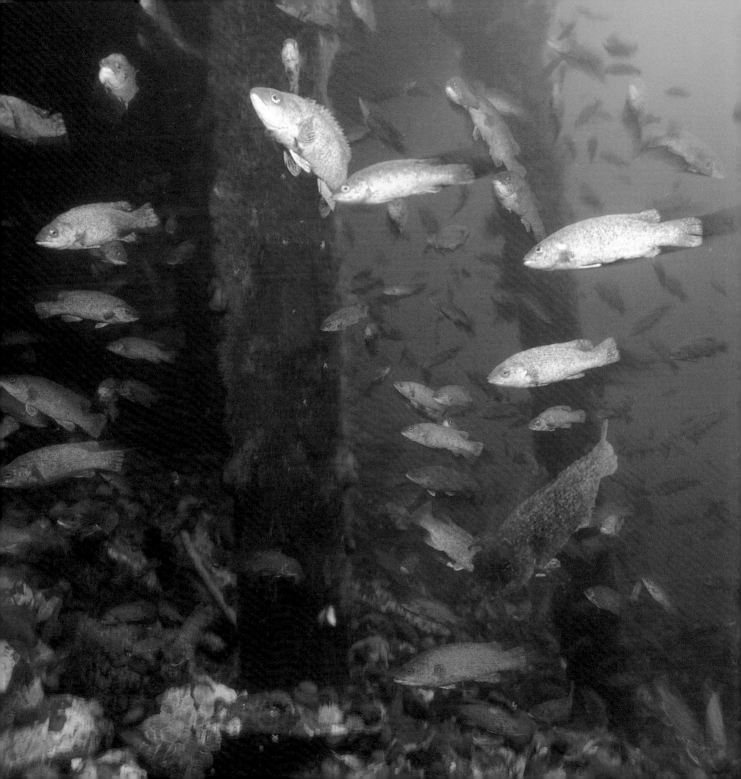

Chapter 1

Bizarre Biodiversity Below

"IF THERE IS MAGIC ON THIS PLANET, IT IS CONTAINED in water." The words of naturalist Loren Eiseley ring truer now than when they were penned five decades ago. It was once thought that the most important ingredient for life was light. We've known for a long time that plants use sunlight in photosynthesis. Light was the stuff on which every living being ultimately depended, or so we thought. Now we know that some forms of life, such as certain cave-dwelling species and organisms living in the deepest ocean abyss, can, in fact, live without light. But there is no life that can survive without water. It is the one thing the biosphere cannot do without. Eiseley was right. Water does contain magic, and the Bay of Fundy shows us this in so many ways.

Facing page: Cunners, seen here swimming beneath a wharf on Brier Island, Nova Scotia, are members of the wrasse family. They are quite intelligent and aggressive, showing little fear of intruding divers.

Below: A group of cunners moves in for a closer look. These irascible fish will sometimes attack their own reflections in dive masks or camera lenses. Particularly bold individuals will tug at a diver's whiskers.

Facing page: This brilliant northern red anemone is one of the most spectacular animals in the Bay of Fundy. Its many tentacles have sticky tips that are used to capture small prey. Though sedentary animals, anemones can release themselves from the bottom and swim freely to look for a new home.

The wind pushes against the tide, throwing the ocean into a fit of nasty, white-capped waves. With its diesel engine labouring, our large lobster boat rolls through the rough seas and oncoming tidal current for an hour before we arrive at our destination: Gull Rock, a prominent reef at the southern approach to the bay.

At first glance, Gull Rock, 3 kilometres off Nova Scotia's Brier Island, looks like the arching back of an enormous whale that is beginning a dive. A few metres high and perhaps 50 metres long, it appears unremarkable

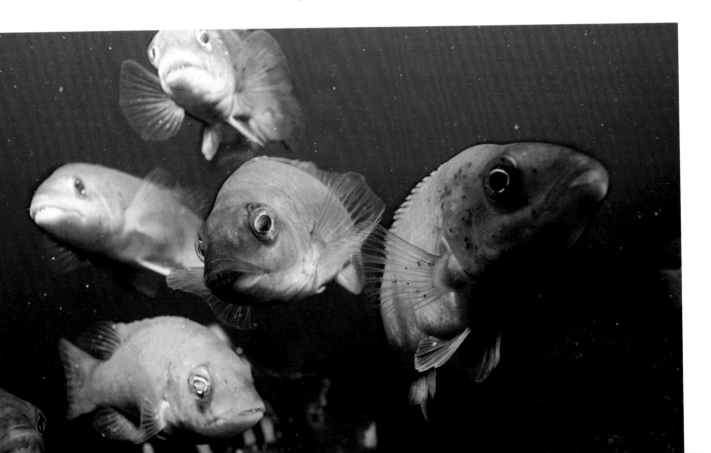

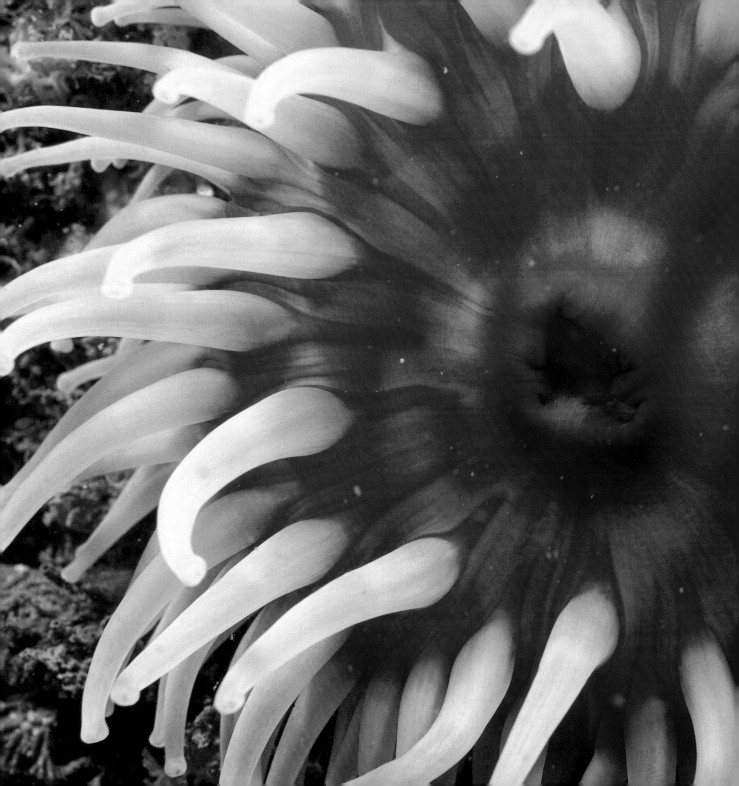

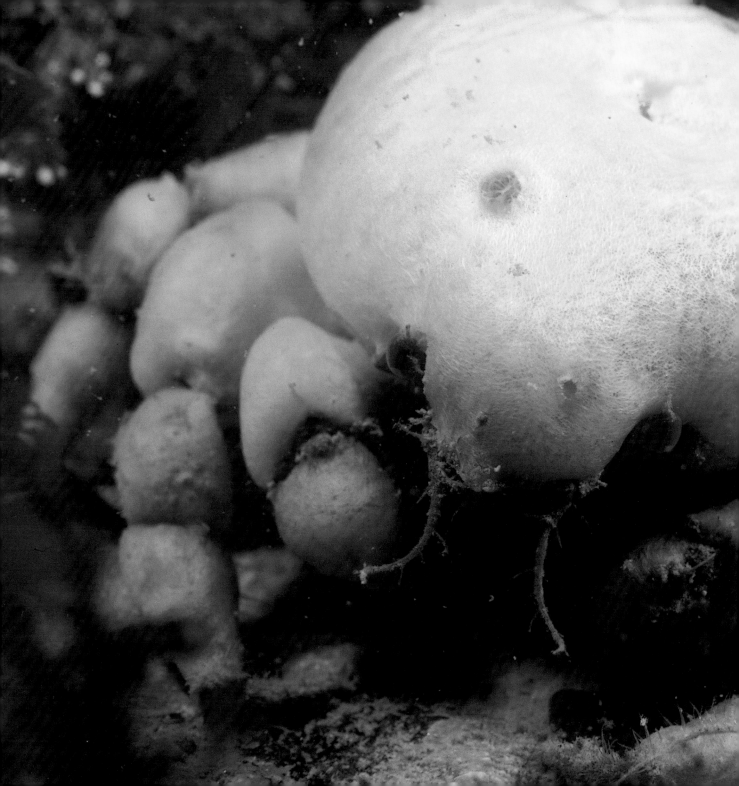

save for a flock of resting gulls and a herd of sunbathing harbour and grey seals. That's above the water. Below, it is anything but unremarkable.

Swept by the powerful tides, this pinnacle of basalt (the kind of rock upon which much of the bay rests) rises some 30 metres from the sea floor to the surface. Like many spots in the Bay of Fundy, it is home to an incredible array of vibrant life forms, many of which are so distinctive they belong to their own unique category of life.

The incoming flood tide brings a mixture of minute animals and plants, known as plankton, which fuels Fundy's ecosystem. Zooplankton is comprised of tiny drifting animals, including jellyfish, larval fish, and larval crustaceans such as baby lobsters, which drift at sea waiting for a new place to call home. However, it is mostly made up of copepods, minute shrimp-like invertebrates about the size of a grain of rice. Copepods are a vital strand in the ocean's food web and are probably the most numerous animals on Earth. They feed on phytoplankton, tiny plants that, as the very foundation of that web, are the single most important source of food in the ocean. And there are lots of them—one teaspoon of seawater can hold a million phytoplankton plants. Truly the pastures of the sea, these diminutive organisms are the predominant engines of photosynthesis on the planet, absorbing light

Facing page: Parasitism is taken to an extreme as this small toad crab has been completely covered by an encrusting sponge. Eventually, the sponge will likely become so thick that the crab won't be able to flex its joints, ultimately resulting in its death.

from the Sun and converting it into organic matter. Comprised of mostly diatoms and dinoflagellates, abundant phytoplankton is the main reason for the greenish tint of Fundy's water.

Bad weather is forecast, it's starting to rain, and the wind is picking up, so despite the current that's running now, I decide to do a dive right away instead of waiting for slack tide.

By entering the water close to Gull Rock on the downstream side, I'll be in a calm area known as an eddy where there's protection from the 4-knot current ripping past on either side. After carefully manoeuvring the boat near the hazardous reef, the captain positions me as close as possible to the rock. Suited up in scuba gear and carrying my underwater camera, I roll over the side of the boat into the sea. The water is only 6°C so I'm glad to be sealed inside my warm neoprene drysuit. I swim down the nearly vertical rock face to a depth of 15 metres. Through the lens of my diving mask, I see my destination below: a rocky plateau of kelp jutting from the side of Gull Rock. Shafts of weak light dance about below me before being absorbed into the opaque depths. Small tornadoes of water spin off the passing currents into the still water of the eddy behind the reef. The turbulence has

Facing page: One of the most elegant and fragile of all Bay of Fundy animals is the red-gilled nudibranch, seen here on the tentacles of a frilled anemone. The waving "tentacles" on its back are actually gills.

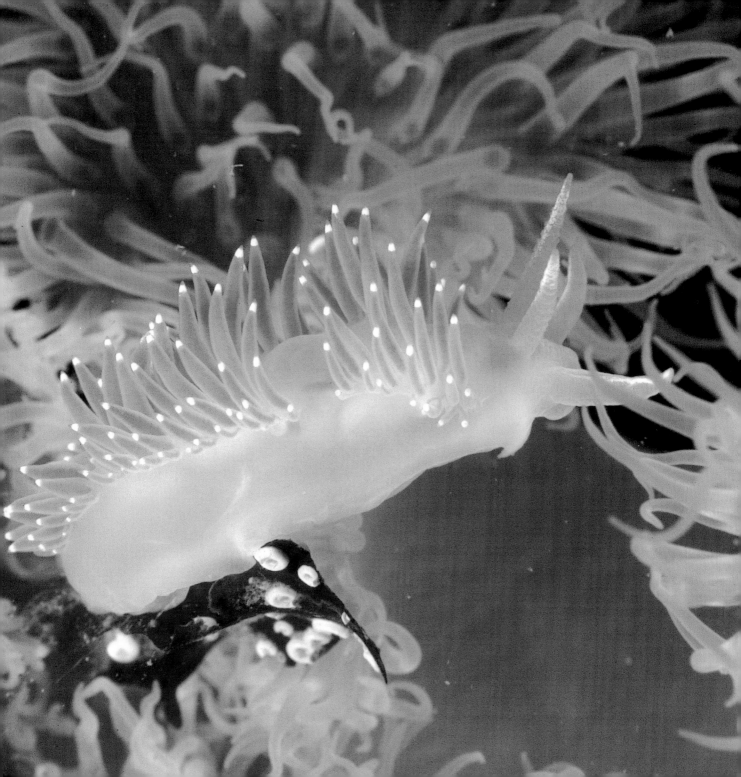

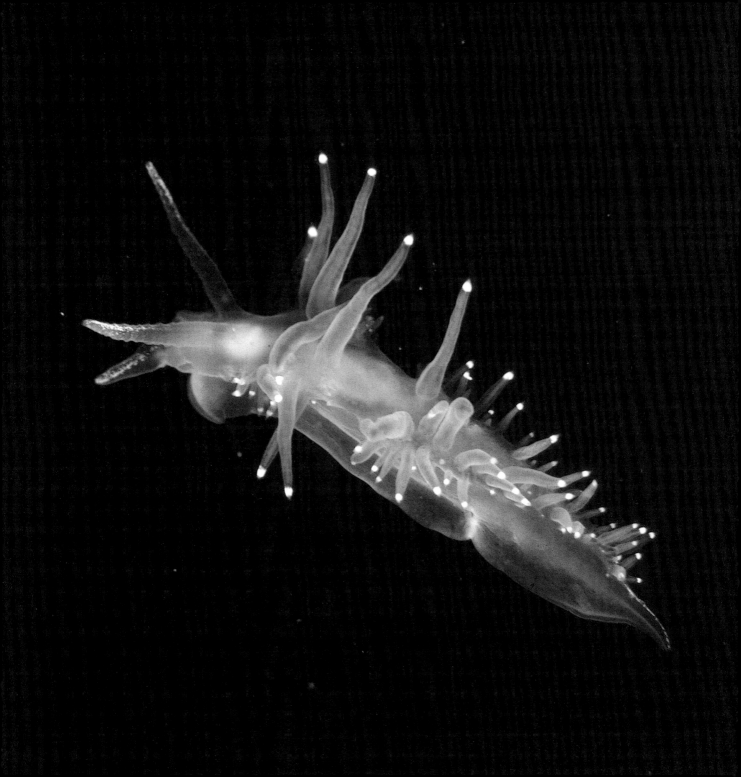

twisted six-metre long stalks of kelp together like rubber bands.

A myriad of oddly shaped animals, such as fan worms, sea anemones, nudibranchs, lampshells, sponges, and sea peaches, cling to the rock, creating a rococo tapestry of bright colours in the murkiness. Such a rainbow of life usually conjures images of colourful Caribbean or Indo-Pacific waters, not the cold waters of the northern sea.

This multitude of body designs, categorized in groupings called phyla, illustrate a basic difference in biological diversity between the sea and the land. (A phylum is a major grouping of life based on the body plan of its members—if we represent all of life as a tree, phyla would be the relatively few large branches growing from the trunk, while species would be the many leaves.) Practically *all* animals we see on land, including birds, mammals, reptiles, amphibians, and even insects, belong in just two phyla. On this one little reef beneath the Bay of Fundy, however, I found at least seven different phyla of animals. Each of the seven has a unique body plan and differs more from the other six than a human would differ, for example, from a primitive animal called a sea peach. That's because, despite its sponge-like appearance and billion-year-old provenance, at one point early in its life cycle the sea peach posseses a rudimentary

Facing page: Floating in the blackness like some bizarre spacecraft, this red-gilled nudibranch is actually a shell-less snail. They are also known as sea slugs and have a reputation for tasting bad. For this reason, they have few natural predators.

spinal cord, which puts it squarely in the same phylum as humans and all other chordates. So sea peaches are actually more closely related to us than they are to sponges. Strange, but true! And strange new species continue to be discovered in the bay. In 2003, two kinds of flatworms, previously unknown to science, were discovered.

In the relative calm of the eddy I settle on some bare rock beside the living tapestry and begin photographing. Because of the small size of my subjects I am using a

Life beneath the waves is all about taking advantage of your neighbours as this colony of hydroids, known as "snail fur," is doing to an Acadian hermit crab. Although many such relationships are mutually ben-eficial, it's hard to imagine what benefit the crab derives from this arrangement.

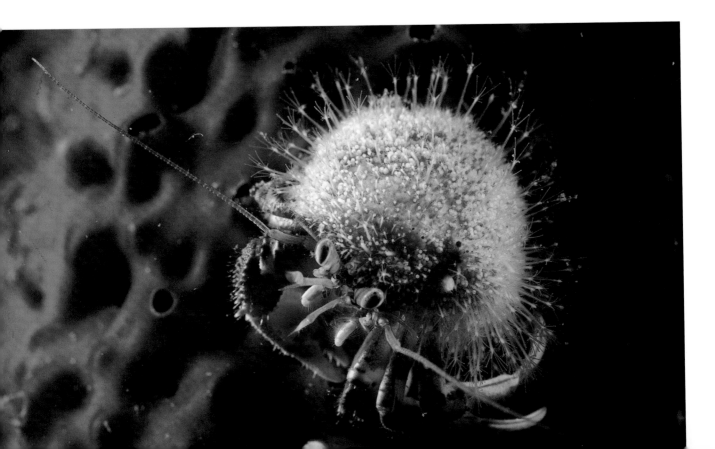

close-up macro lens and underwater flash units. This way I can capture the minute details of some of the most unusual species of all.

Despite their clam-like appearance, northern lampshells aren't related to clams, mussels, or any other mollusc. Members of a separate phylum called Brachiopoda, they possess a lace-like "hand," called a lophophore, which they wave through the water to scoop up microscopic bits of food. This ancient group of animals dates back to the dawn of multicellular life over 500 million years ago in

No relation to shellfish, these northern lampshells in fact belong to a completely separate group of animals known as the brachiopods, some of the most ancient organisms on Earth. Certain members of this family have changed little in over 500 million years.

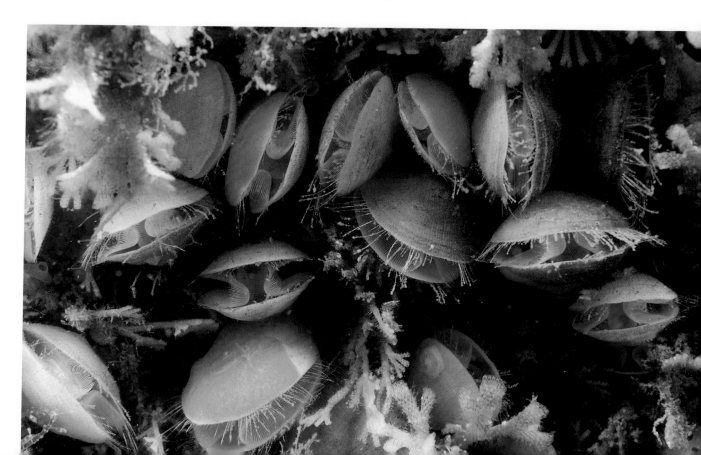

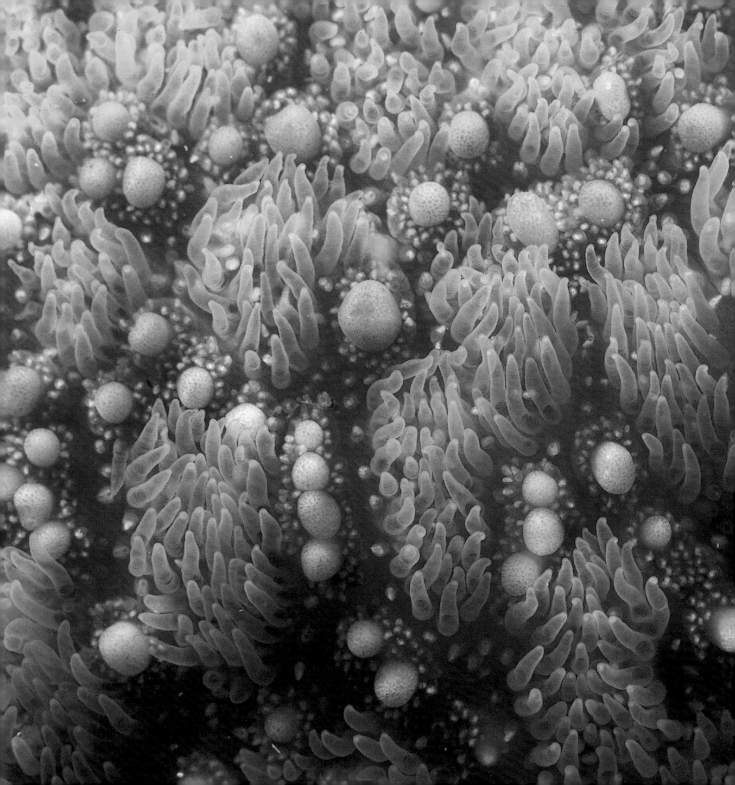

the early Cambrian Era. About 12,000 different fossilized species have been found, making brachiopods one of the most successful designs in the history of life on Earth. Today, they are considered "living fossils" and are among the oldest surviving species on the planet.

Nearby I find a nudibranch (pronounced new-di-brank) on a frond of kelp. Basically tiny, shell-less, cigar-shaped snails, nudibranchs possess a prominent mane of external gills on their backs and a pair of long "nose" stalks called rhinophores. As bizarre as their appearance

Facing page: In close-up, the top of this northern sea star takes on the appearance of an aerial photo of a fantastical forest. Larger rounded spines are visible among hundreds of small pincer-like projections called pedicellaridae.

Below: The name of this organism, the slimeworm, belies the beauty of its radiole, which resembles a Japanese umbrella when open. When disturbed, however, this primitive animal will retract itself in a slimy, transparent casing on the rock.

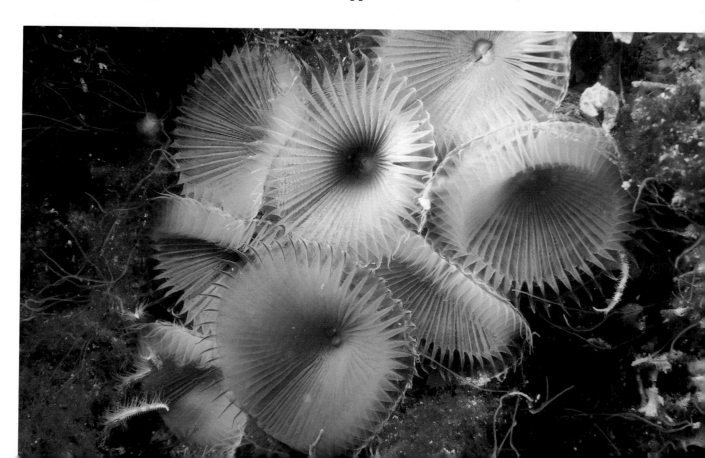

Facing page: A long-horned sculpin, resting on some red vegetation among the rocks, is a bottom-dwelling species usually found in sandy areas where its mottled black-and-brown colouration allows it to blend in with its surroundings.

Below: Generally preferring deeper water than rock crabs and hermit crabs, this toad crab crawls over a green sea urchin while looking for food.

is, even odder is the fact that they are rarely eaten because apparently they taste very bad, although it's hard to imagine a researcher tasting a nudibranch in the name of science!

Tucked away in sediment at the bottom of a crevice in the basalt, a group of northern red anemones sits like an undersea garden of fat, succulent flowers, the colour of roses and violets. Their beauty belies the fact that they are efficient predators that use sticky tentacles to capture little animals that drift by. Fossil evidence found 1,200 kilometres

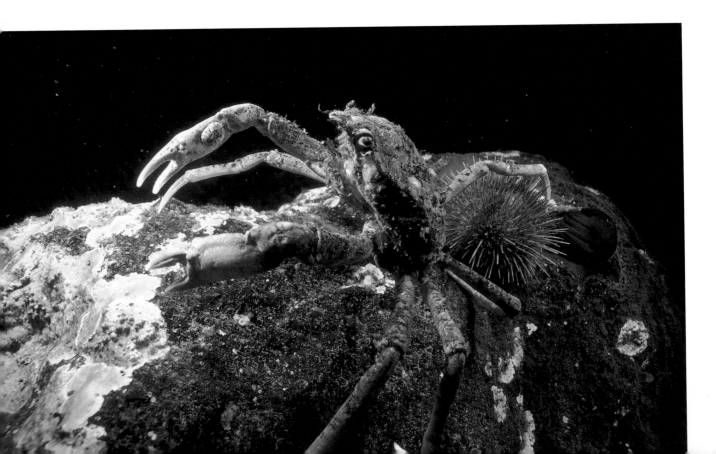

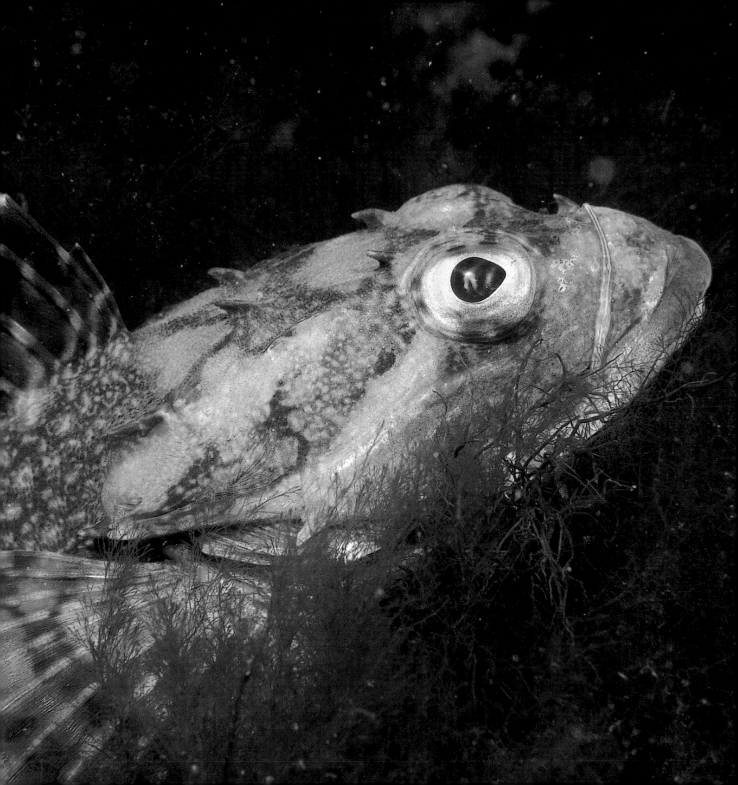

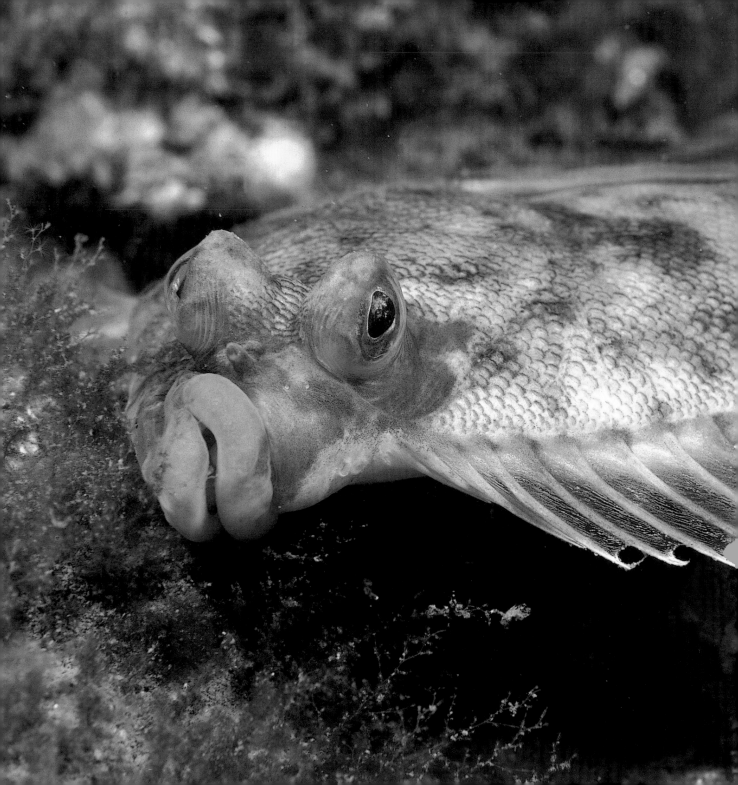

away at Mistaken Point on the coast of Newfoundland suggests that anemones and their ilk are descendants of some of the first complex multicellular life forms to have evolved on Earth. Nearby, hidden beneath an overhang, is another bizarre animal that attests to the inventiveness of evolution in the sea. Fan worms, which attach themselves to rocks, don't look like worms at all. They hunt by spreading an elegant, umbrella-like fan, known as a radiole, which is used to snag plankton and other small bits of food floating past.

By now, it should be apparent that many of the most unusual animals in the Bay of Fundy contradict our usual notion of what it means to be an animal. Many organisms in the sea are basically stationary and don't move around much, if at all. To those of us born above the tide line, this might seem a strange way to get a living, but when you think about it, it is a brilliant strategy. Why waste all that energy moving around when you can just wait to gather your food as it drifts by in the water?

These primitive, spineless animals are not the only

This close-up of a winter flounder shows its bizarre Picasso-esque face. Although born with a symmetrical head like other fish, as it gets older its left eye gradually migrates to the right side of its head.

wonders, though. Larger, more familiar denizens abound. Farther down the reef in deeper water, a group of curious cunners (a species of wrasse also known as sea perch) emerges from the darkness beneath a kelp-covered rock overhang to check me out. Cunners are colourful, intelligent fish whose inquisitiveness can sometimes seem like mild aggression to a diver. They have pecked at the glass dome of my camera repeatedly (perhaps attacking their own reflection), bumped into the lens of my diving mask, and nipped at my beard. This time they are more congen-

A rock crab rests against a basalt boulder covered in pink coralline algae that matches its colour.

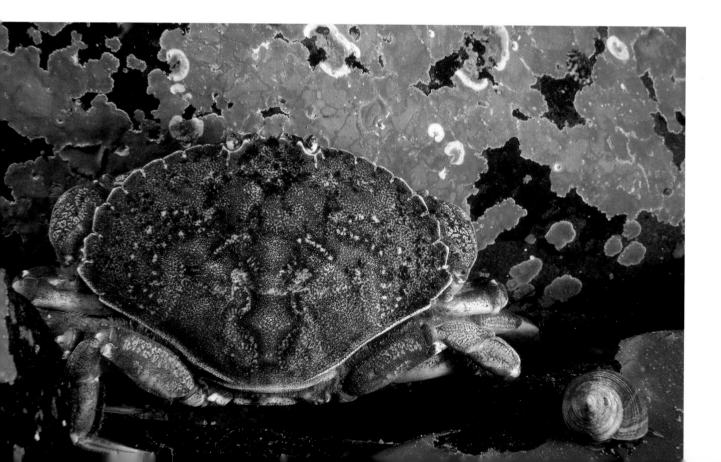

ial, letting me photograph them at close range with a wide-angle lens. Cunners are generally small, but can grow up to 40 centimetres in length, and are found in a variety of colours from rusty orange to blue or brown. They prey on mussels, sea urchins, worms, and crabs. Like other generalist species, cunners are able to adapt to a variety of conditions, and though not fished commercially, they have learned the art of stealing bait off hand-line hooks without getting caught, a habit that hasn't endeared them to inshore fishermen.

Aptly known as an ocean pout, this relatively large eel-shaped fish can grow to a metre in length. It hunts by lying still in wait on the bottom, then ambushes potential prey that swims by.

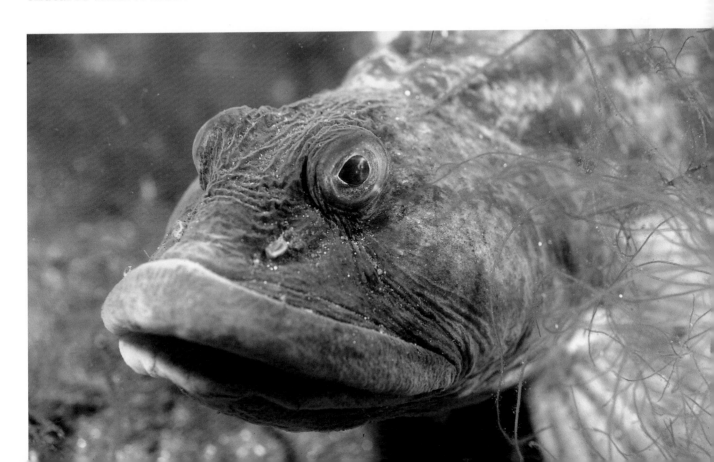

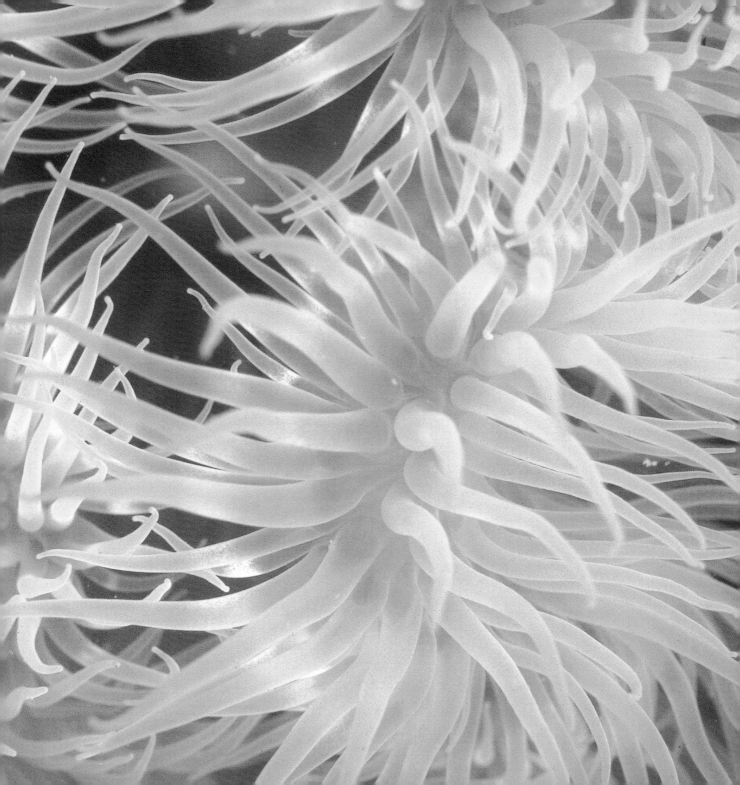

Thirty-five metres down I finally arrive at the base of Gull Rock. This is about as deep as one can usually dive without using the special mixtures of breathing gases designed to lessen the likelihood of getting the bends, a dangerous and sometimes deadly side effect of diving. The pressure here is four times as great as on the surface, making breathing from my regulator more laboured, and I use up my air four times as quickly. I can't see the Sun above me, only an opaque dome of green Atlantic water. It's almost completely dark at this depth and kelp has a

Facing page: Up to 1,000 small tentacles are found on larger frilled anemones such as this one, photographed in close-up. Small threadlike organs called acontia, carrying stinging nematocysts (not strong enough to sting a human), can be extended when an animal is disturbed.

Below: Peering from a clump of sea lettuce, this sea raven lies in wait for prey. Though a voracious eater with an enormous mouth (I have seen one swallow an entire long-horned sculpin that was almost as big as it was), sea ravens seem to be curious about divers and can be stroked like a puppy.

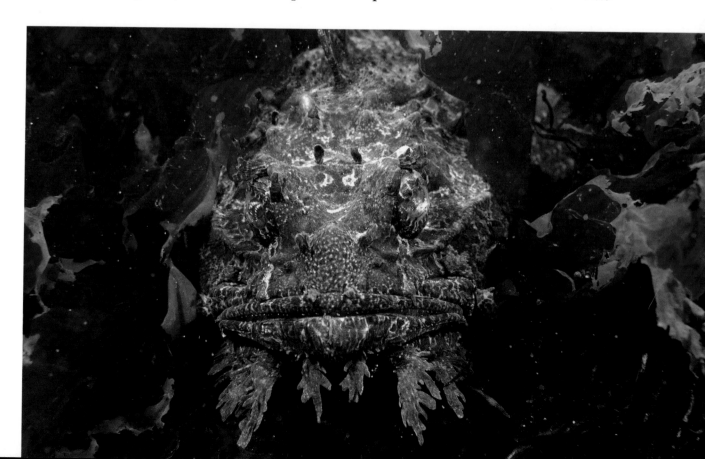

hard time carrying on photosynthesis, so there is little of it around. A relatively barren and flat sandy bottom stretches away from the rock into the murkiness. But, as they say, life abhors a vacuum, and I find a 1-metre-long ocean pout rolled up like a fire hose beside a small boulder. It's apparently not interested in me at all, and allows me to approach it closely. This aptly named fish waits patiently for prey to swim or sidle by, then engulfs it with a huge mouth rimmed by big, pouty lips.

After about thirty minutes of exploring and photographing, I'm beginning to run low on air and I sense a change in the sea around me. The eddy that has protected me from the current is starting to disappear. I ascend toward the world of sunlight, doing so slowly to avoid getting the bends. Closer to the surface the kelp is flapping horizontally in the tide, pennants in an aqueous gale. I take shelter behind a rock to find some protection, but the powerful current captures me. After one last look at the wealth of strange and beautiful marine life inhabiting this unlikely oasis in a cold sea, the tide snatches me away from Gull Rock and I finish my ascent.

Facing page: A garden of frilled anemones cling to a boulder. The middle one shows its 4-inch-long stalk, while the surrounding anemones have retreated inside themselves.

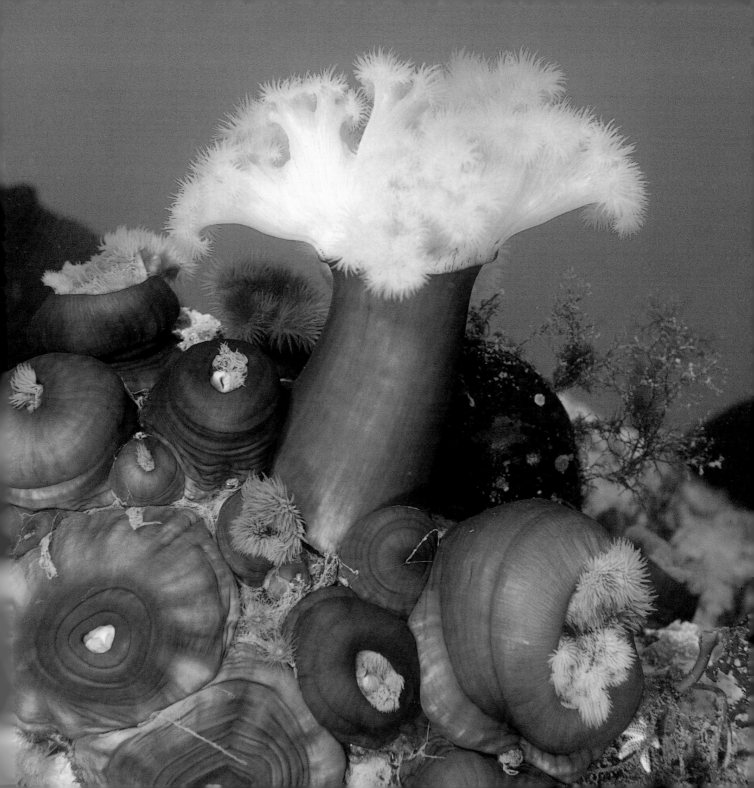

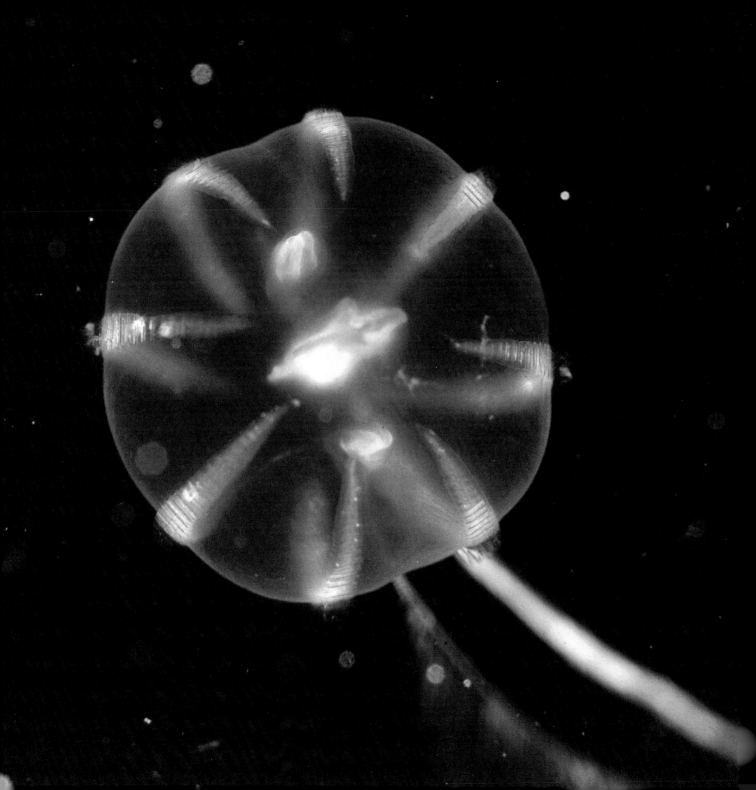

Crystals in the Sea

DESCENDING THROUGH THE COOL SUMMER WATER of the Bay of Fundy with my camera at dusk, I pass through a constellation of small, semi-transparent yellow jellyfish. Though just a few centimetres across, many of them carry a cargo of undersea hitchhikers: minute shrimp-like animals, clinging tenaciously to the bells of the jellies.

Many small marine animals hitch rides on larger ones in this manner. Jellyfish, moving as slowly as they do and unable to shake off would-be riders, are particularly popular hosts for tiny freeloading passengers. With little in the way of sensory apparatus, the jellies seem quite unaware of their cargo. They are often used as "water taxies" by tiny larval invertebrates such as lobsters, crabs,

Facing page: The radial symmetry and transparency of a sea gooseberry is apparent in this unusual top-down photograph.

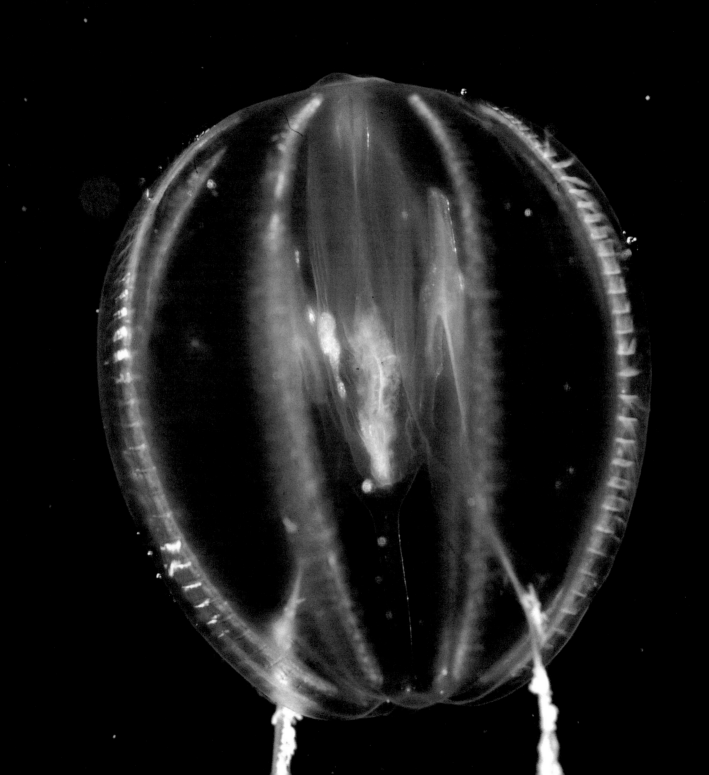

and other animals that hitch a ride to new habitats. As well, small silvery fish, usually juvenile pelagic species, can occasionally be seen among the tentacles of large jellies such as the lion's mane. Some unfortunate jellies also are host to internal "hitchhikers," parasites such as amphipods and copepods, which burrow into the jellies' guts, eating them from the inside out.

Photographing any animal that drifts in mid-water is particularly difficult and the small size of these jellies makes it more so. The lack of a solid surface for a reference

Facing page: In this close-up of a sea gooseberry, also known as a comb jelly, the swimming plates (actually fused together cilia) can be seen running along each of the "combs."

Below: This lion's mane jellyfish emerges from the nighttime darkness in the Bay of Fundy.

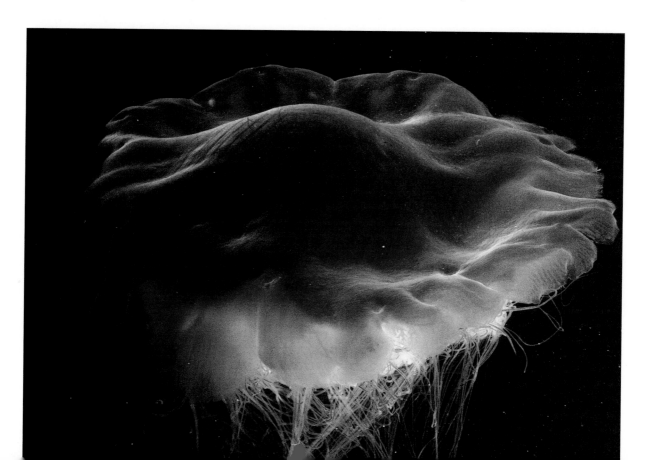

point could result in potentially lung-damaging pressure changes for me if I move up or down in mid-water, while unwittingly holding my breath. To make matters worse, looking through a small viewfinder with the other eye closed adds to the difficulty of maintaining position. I must adjust my buoyancy very precisely so I can hover steadily in mid-water.

Because an abundance of jellies at any given place is unpredictable and their position in the sea is completely at the mercy of ocean currents, I am fortunate to find as many as I have. Working quickly, I set exposure, adjust strobe lights, and focus the lens to capture these little jewels on film. Time is of the essence; I have only about fifteen minutes of still water before the tide begins to ebb.

The animals that we commonly know as "jellies" drift through the Bay of Fundy in their billions, like inner-space voyageurs. They are referred to as macro-plankton, (from the Greek for "large wanderers") and like other plankton, they generally float passively in the boundless sea. Translucent, and often as beautiful as crystal, their life's journey through the ocean is controlled more by tides and currents than by any primitive instinct or loco-motive ability they might possess. They are a truly ancient family, having plied the oceans of the world for hundreds of millions of years.

Facing page: The iridescence displayed by members of ctenophora such as *Mertensia ovum* and sea gooseberries is often mistakenly thought to be bioluminescence. In fact, it is caused by light refracting off the cilia as they wave up and down the comb.

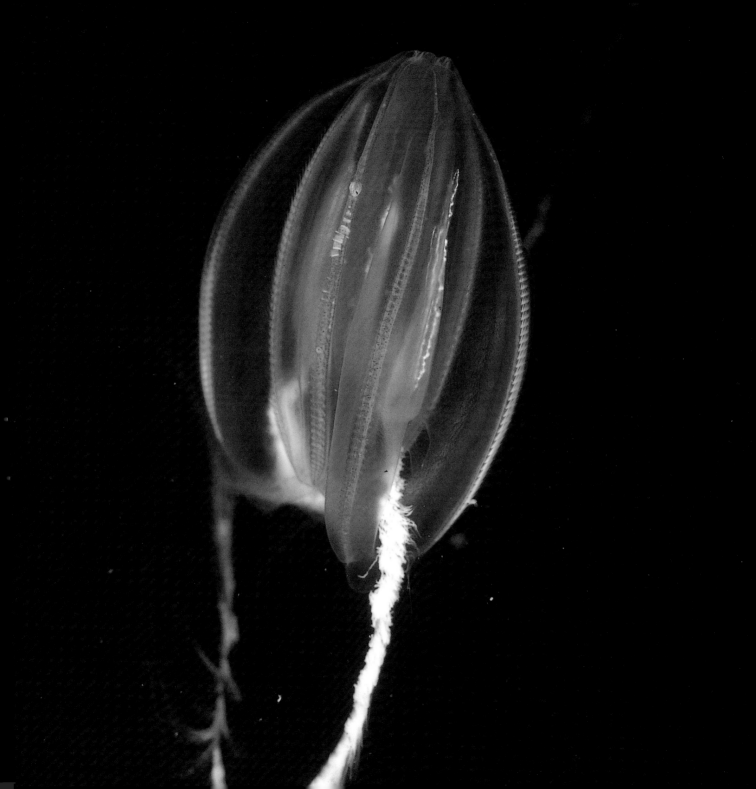

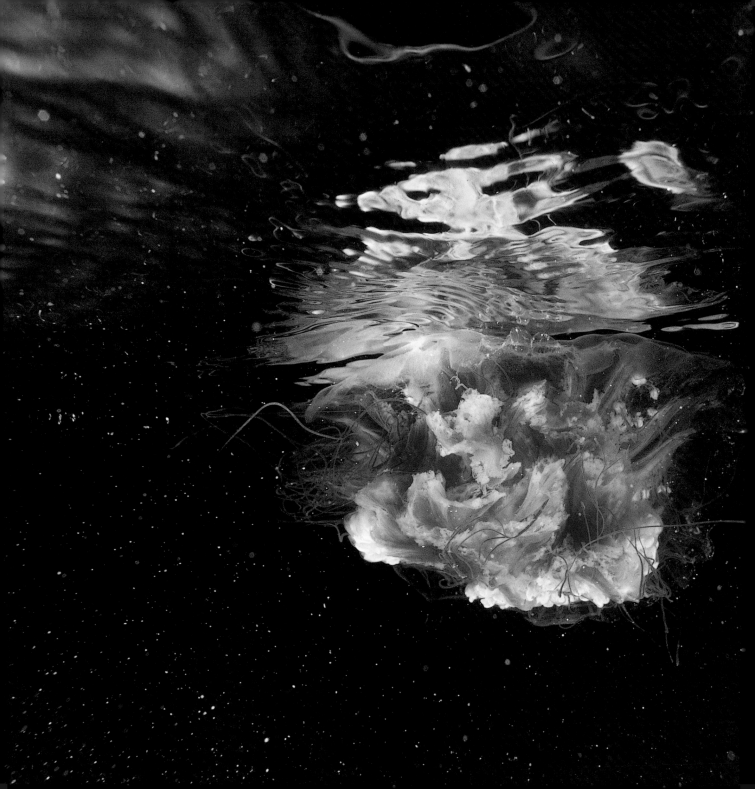

Left: Reflected against the surface at night, a large lion's mane jellyfish takes on a grotesque shape, revealing a mass of tangled poisonous tentacles that contain millions of highly complex stinging cells known as nematocysts.

Below: Though similar in appearance to a sea gooseberry, *Mertensia ovum* is a larger, generally more northerly ranging species.

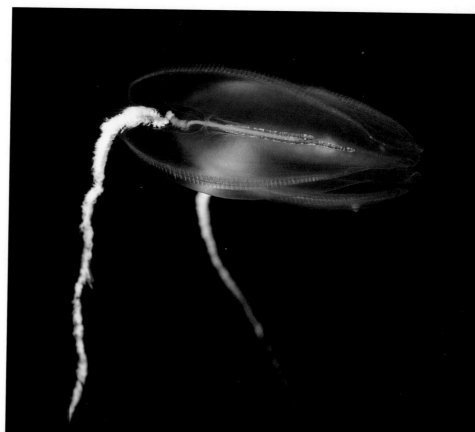

Facing page: Constricted jellyfish have thirty-two thread-like tentacles that can be coiled like springs. The frilly yellow reproductive organs and four vertical canals are visible through the transparent bell.

Some 200 species of the true jellyfish (the typically familiar ones with a pulsating bell and trailing tentacles) live throughout the world's oceans. The Bay of Fundy is home to a number of them, including the largest of all, the lion's mane jellyfish, which can reach a diameter of 2.5 metres and have tentacles over 15 metres long. This large jelly has only one natural predator we know of, that antediluvian giant wanderer of the seas, the leatherback turtle.

All "true" jellyfish, which belong to the *Cnidarian* (the "C" is silent) family, have the ability to inflict at least

Right: This constricted jellyfish shows the characteristic "waistline" it is named for. Like other jellies, it is about 95 percent water. In the ocean, the most efficient way of living is to produce the least amount of body tissue while still being capable of reproduction, so many organisms that are free-floating are composed almost entirely of water.

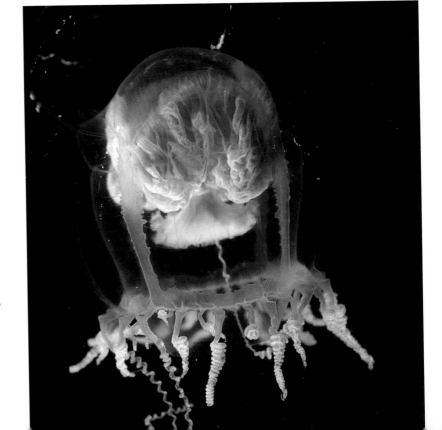

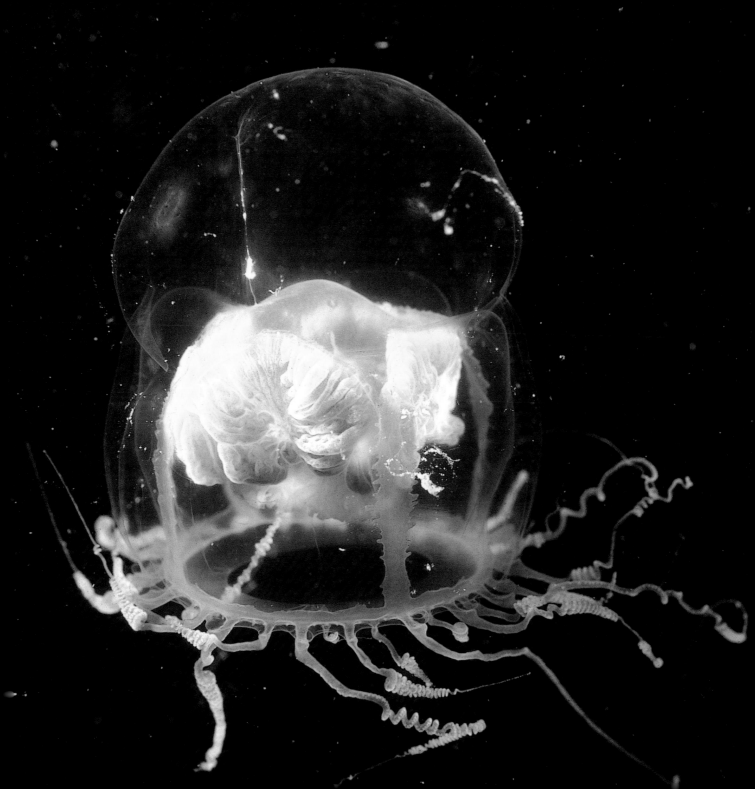

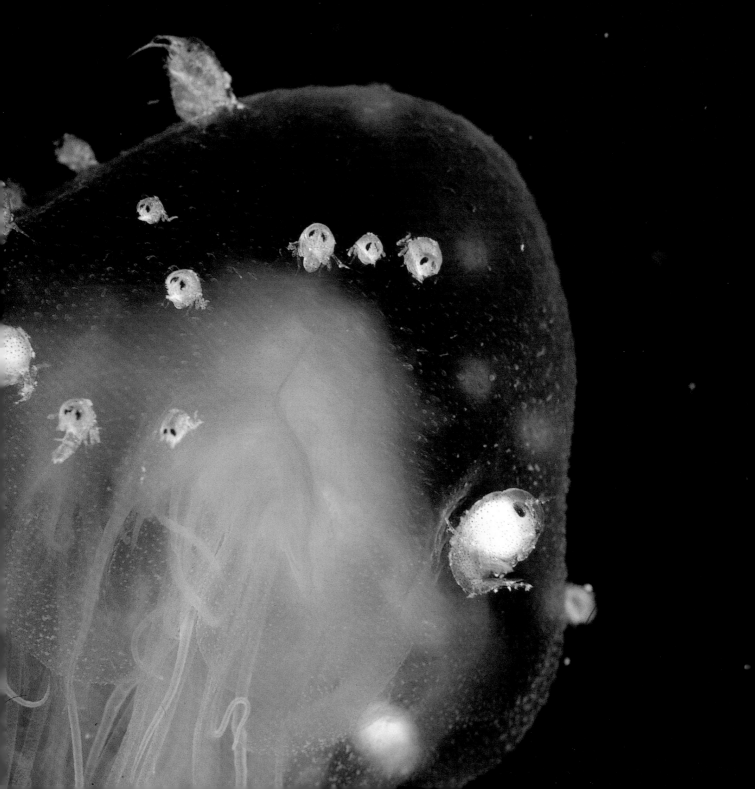

some pain. *Medusae*, as they are formally known, are characterized by the presence of specialized stinging cells called nematocysts. These tiny harpoon-like weapons literally explode to inject neurotoxins into a foreign object such as an unsuspecting swimmer's hand. Oxford biologist Richard Dawkins referred to these "harpoons" as "probably the most complicated piece of apparatus inside any cell anywhere in the animal and plant kingdoms." Having accidentally swum headlong into a tangle of lion's mane tentacles once while I was ascending from a dive, I can attest

Facing page: In this extreme close-up, tiny, shrimp-like hitchhikers are visible on the bell of this jellyfish.

Below: Looking like egg white and yoke, this jellyfish carries a cargo of freeloading creatures on its journey through the ocean. That such an arrangement is good for the tiny crustaceans can't be disputed—they hitched a ride in an effort to disperse to a new location. Whether it benefits the jellyfish is another question.

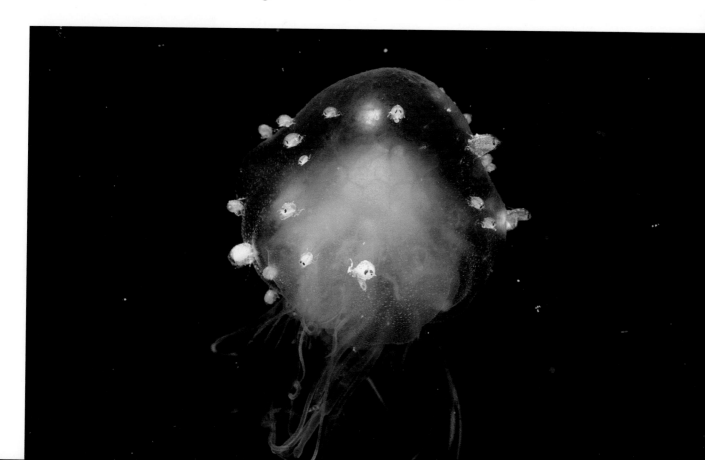

Below: This unidentified species displays elegant simplicity and beauty as it drifts through the bay at night. Only 15 millimetres or so tall, it may be a larval stage of a larger animal.

Right: Illuminated by penetrating sunrays, a lion's mane jelly, trailing its toxic thread-like tentacles, lifts its bell like a bird raising its wings as it swims gracefully through warmer water near the surface of the bay.

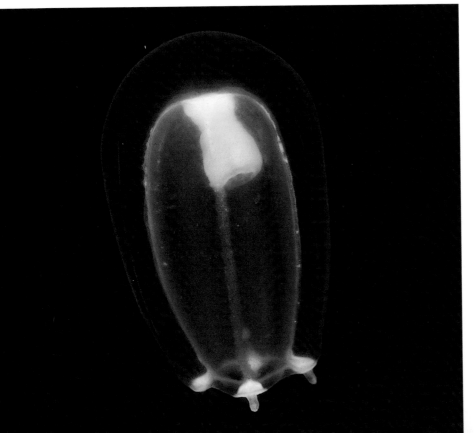

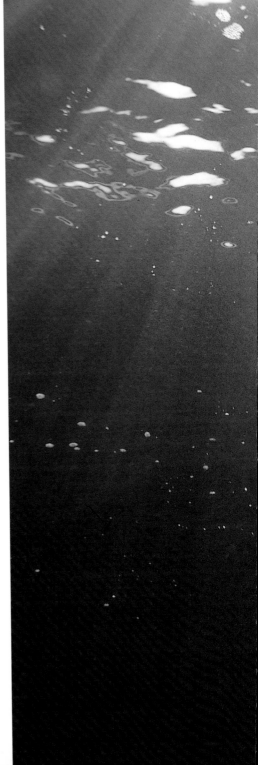

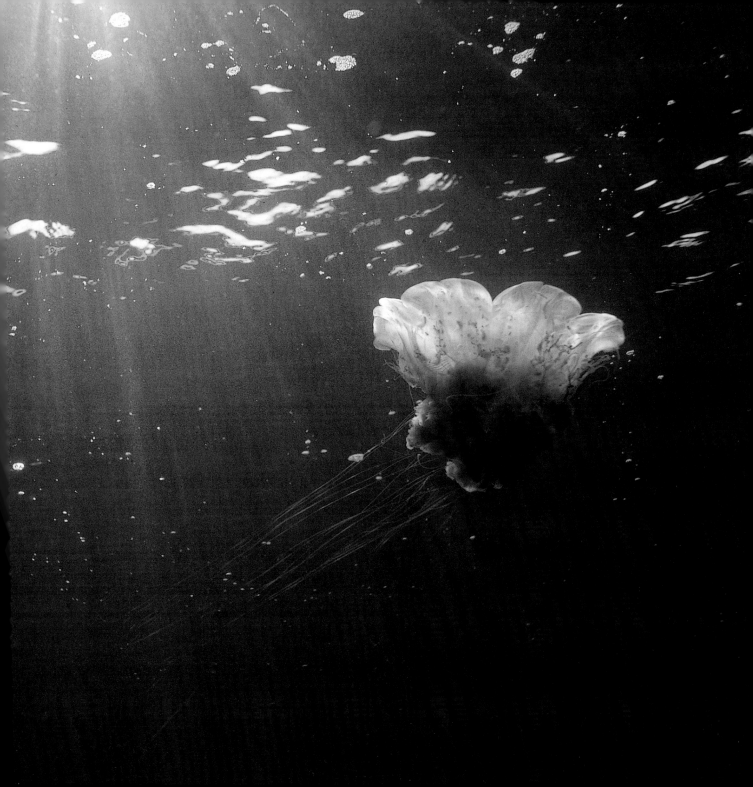

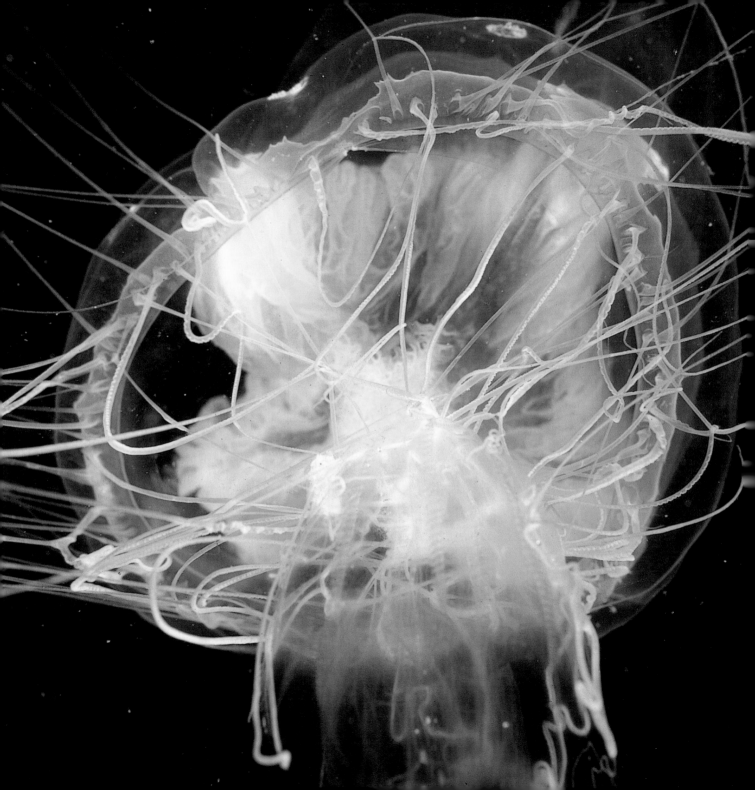

to the agony-inducing power of these tiny "harpoons." I was immediately afflicted by a most acute, stinging pain. Luckily, after surfacing and rinsing my face with fresh water, the swelling and pain eventually subsided and no permanent damage was done.

Although we generally call anything gelatinous and transparent a "jellyfish," another common group of jelly-like animals in the Bay of Fundy belongs to a completely separate phylum. The ctenophores (there's that silent "C" again)—from the Greek for "comb bearer"—are an even more ancient family than the jellyfish. Despite living in the oceans in staggering numbers, ctenophores are difficult to observe from the surface, and were largely unknown to science until humans began scuba diving. Now we know there are at least 100–150 species living throughout the world's oceans.

Many near-shore ctenophores are small, transparent, and roughly football-shaped with two long, sticky tentacles for capturing and drawing in small prey. Unlike jellyfish, they have no stinging cells. They are commonly known as "comb jellies" for their eight rows of swimming cilia, or combs. Both the sea gooseberry and *Mertensia ovum*,

Two ancient phylums collide in the bay as a small jellyfish has captured and begins to eat a sea gooseberry.

common Bay of Fundy species, move their cilia up and down in waves that look like falling neon dominoes. This phenomenon occurs when the surfaces of the cilia refract the light, splitting it into a spectrum the same way a prism does. This results in a rainbow of colours. Some ctenophores, as well as some of the true jellies and many other types of plankton, also are capable of actually manufacturing their own light through an internal chemical reaction known as bioluminescence. If you've ever been on a boat at night you may have noticed the cool green colour of the bow wave. As the boat passes through the water it disturbs millions of microscopic single-celled dinoflagellates called *noctiluca*, prompting them to light up like tiny green lanterns.

As the world's oceans warm, the distribution and abundance of these gelatinous animals are changing. Enormous population explosions, known as blooms, are occurring in places where jellies were formerly not abundant. Often, they are of species that are completely new to a region. In

The four ring-like reproductive organs of a moon jelly are visible behind the four frilly oral arms. At times, moon jellies are found in astronomical abundance from the Arctic Ocean to Mexico. Rimming the bell are many very short tentacles that give a mild sting.

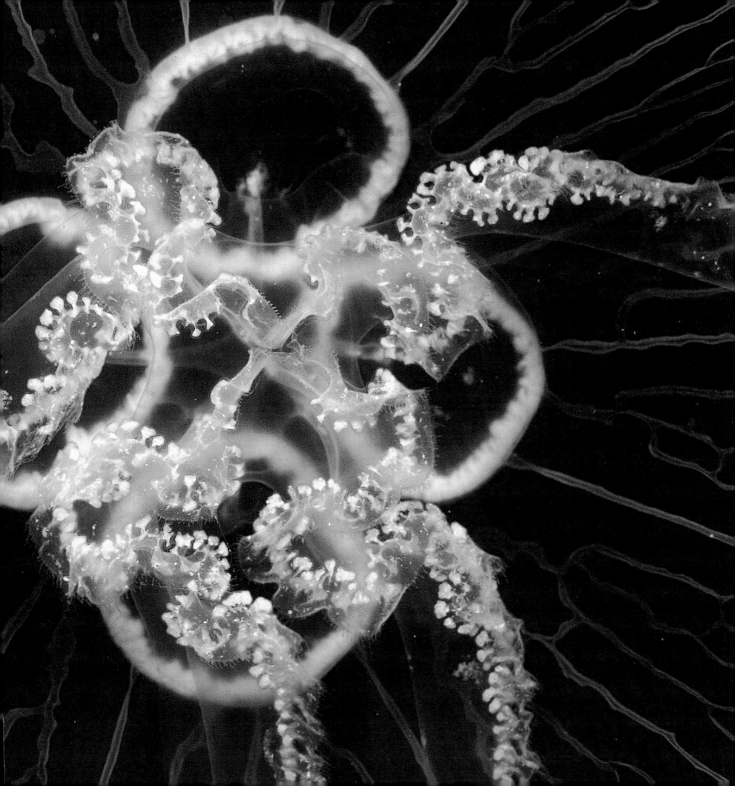

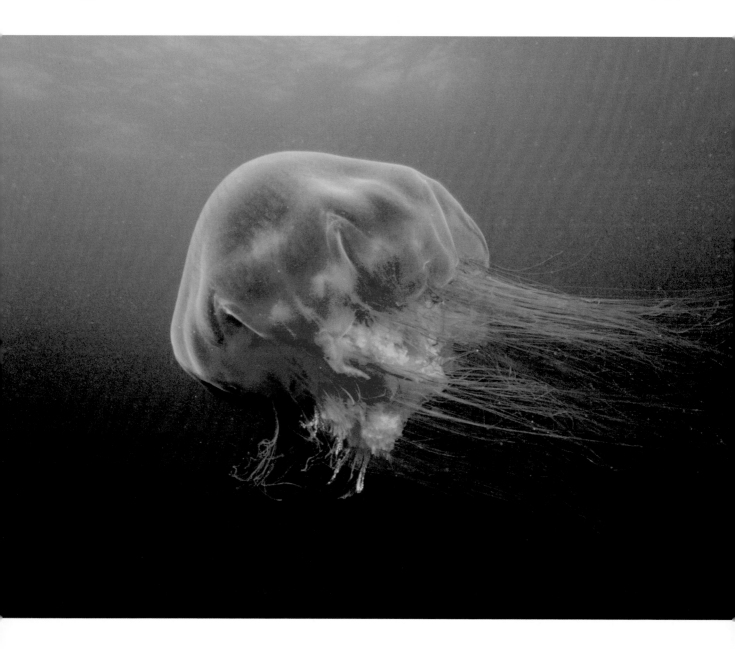

recent years, a bloom of huge 10-kilogram spotted jellyfish, a native of Australia, threatened to wipe out the Gulf of Mexico fishery; comb jellies choked Rhode Island's Naragansett Bay; and jellyfish increased tenfold in the Bering Sea. Although no such near-catastrophic explosions have occurred in the Bay of Fundy, warmer water temperatures in winter may yet trigger a large increase in the jellyfish population as we begin to feel the insidious tentacles of global warming. As beautiful as they are, jellyfish may be the opposite of the "canary in the coal mine" as an indicator of environmental health, for they seem to thrive in conditions, such as higher than normal water temperatures, which may cause problems for other species.

Despite their being a possible portent of trouble in the sea, observing these creatures in the ocean is a thrilling experience. Underwater in the Bay of Fundy at night, virtually weightless in the midst of luminescent, twinkling jellies and plankton, one feels as if suspended in a starry inner space.

Facing page: Spectacular and otherworldly, a large lion's mane jellyfish propels itself near the surface of the Bay of Fundy, displaying brilliant colours and trailing tentacles, which can be up to 15 metres long.

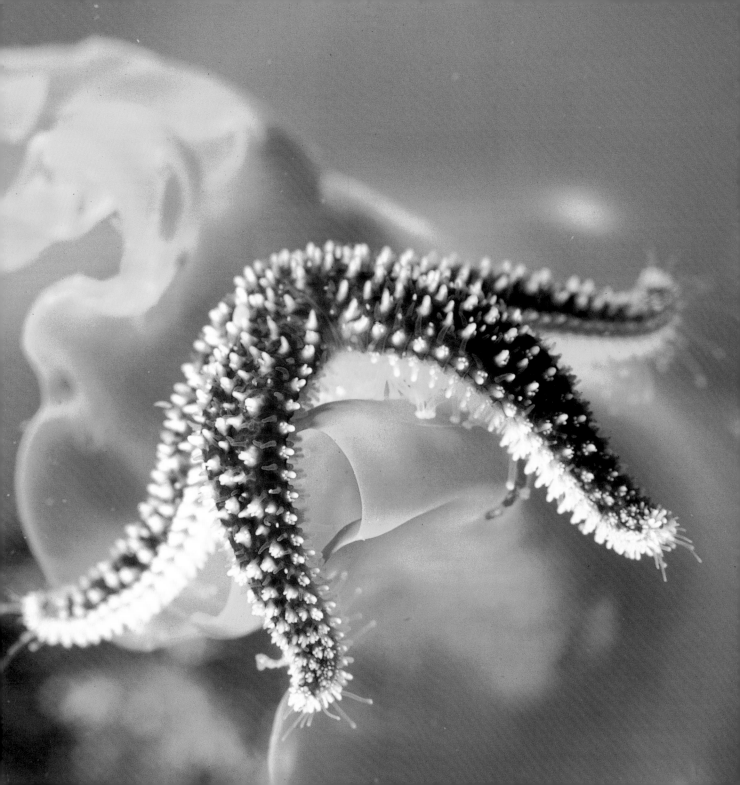

Chapter 3

An Exploration of a Bay of Fundy Kelp Forest

SIX-METRE-TALL *Laminaria* KELP SWAY RHYTHMICALLY in a faint ocean swell as the late afternoon sunlight splays through the dense canopy of vegetation above me. The tide for which the Fundy is famous slips by unfelt in the distance, outside this deep pocket of a cove in the lower bay. There is no current here, just a sanctuary of stillness in restless waters.

The water is unusually clear and the surface, 10 metres above, looks close enough to touch. The ocean floor is a mosaic of dark boulders and patches of bright sand. Sunlight penetrates the thick, overarching fronds and falls with soft radiance on the sea floor like light flooding a cathedral. To say that such a place is beautiful doesn't do it justice. Magical might come closer to the mark. This is a kelp forest.

Facing page: This slender sea star, one of the smallest of the typical sea stars with a diameter of about 50 millimetres, rests on some kelp in its favourite habitat, just below the low tide mark.

Kelp beds are found along rocky shores where boulders, reefs, and smaller rocks provide a secure place for the plants to attach. They circle much of the Fundy, except where mud flats prevail in the upper bay, and are found from the intertidal zone to a depth of about 30 metres. Several species of kelp live here, but those of the *Laminaria* genus dominate. The largest is commonly known as broadleaf kelp, which can grow up to 8 metres in length.

The kelp ecosystem's diverse nature stems from the abundant surfaces on which a variety of animals and

Below: Squirrel (also known as red) hake have sensitive chemical receptors on their tiny chin barbels, their pelvic fins, and on the long ray of the first dorsal fin that help them locate food on the bottom at night.

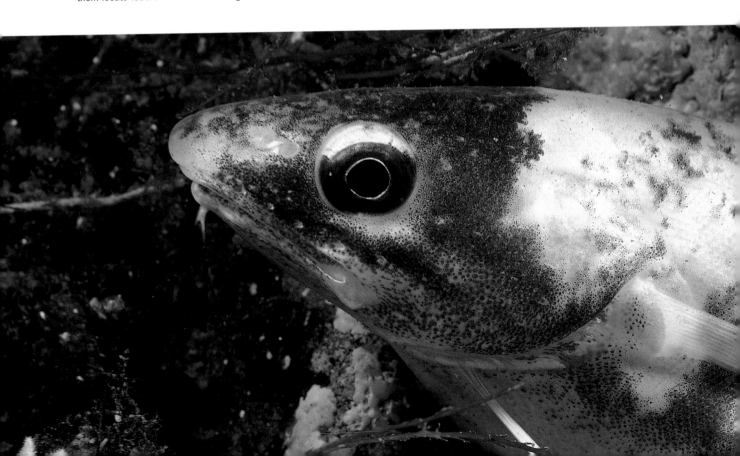

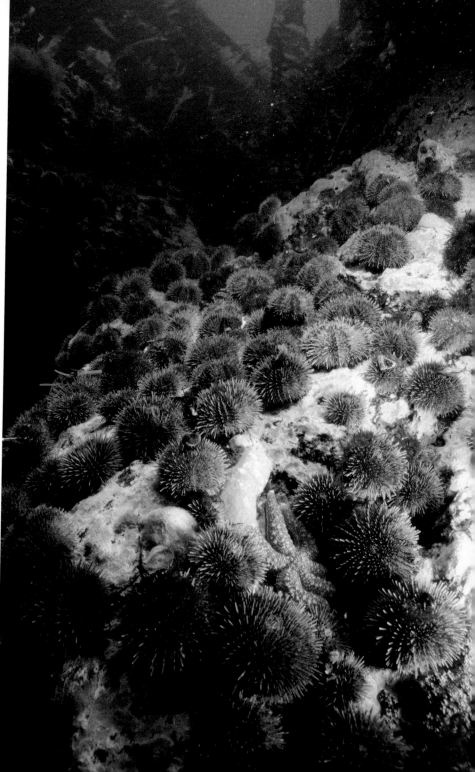

Right: Green sea urchins are the archenemy of a healthy kelp forest. When their populations explode, they invade the kelp and practically mow it down as they eat the stems of the plants, killing them. A rich bed of kelp can be reduced to bare rock in one season. Fortunately, when they have eaten themselves out of house and home, the urchin population crashes, and with any luck, a new kelp bed will eventually grow.

Below: A relatively uncommon spiny sunstar moves across the rocky bottom, no doubt in search of its favourite prey, mussels. For this reason, they are often found in the high-current areas where blue and horse mussels proliferate.

Right: Harbour seals are often the top predator in a kelp environment, feeding voraciously on crustaceans such as crabs and fish such as flounder, hake, and herring. Exquisitely adapted to their environment, they move through the water with grace, putting on an unforgettable show for any diver lucky enough to witness it.

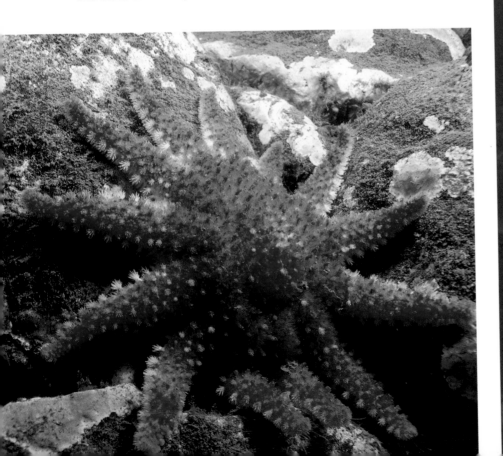

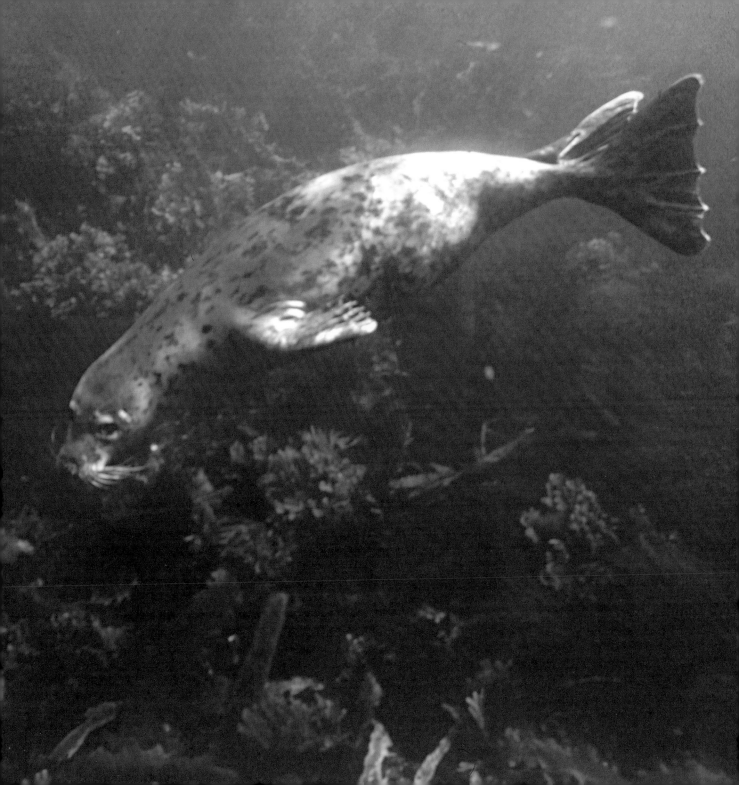

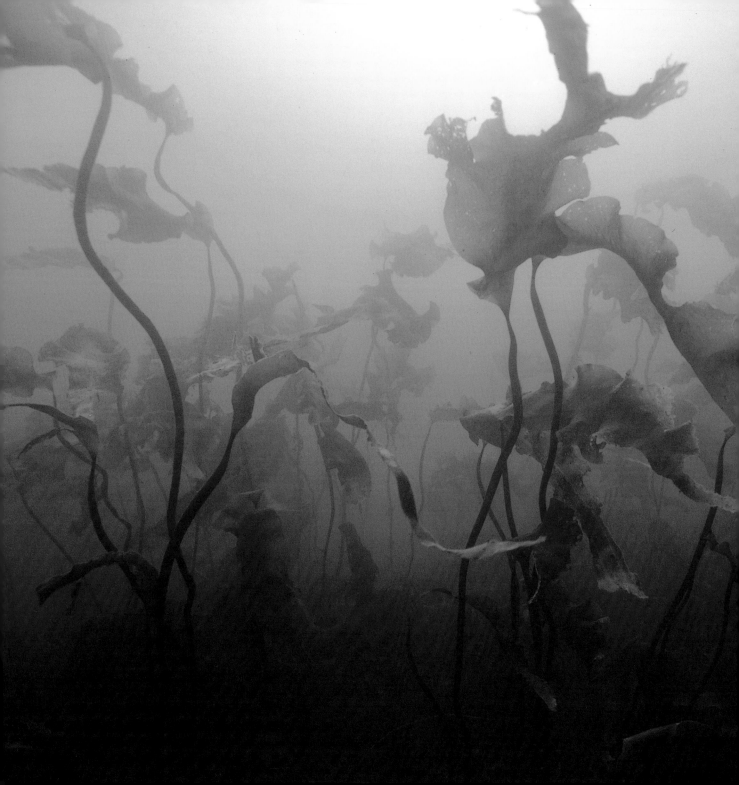

smaller plants are found. In this environment, organisms take advantage of a multiplicity of habitats from the sand between the boulders to the rocky reef, from the stalks of the kelp to its broad fronds. There are more niches here per given area than in any other habitat in the bay, and every one of them is occupied by some living thing. Hundreds of small, stationary invertebrate animals known as bryozoans (a primitive lace-like organism) and hydroids (small jellyfish-like polyps) live on every kelp frond. Dozens of species of worms, molluscs, and

Facing page: Luxuriant forests of fast-growing broadleaf laminaria kelp up to 8 metres tall can be found particularly in the lower Bay of Fundy. Some beds may stretch for kilometres in shallow water along rocky shores, creating a rich habitat for a diversity of marine life.

Below: A hunter with its spoils (and perhaps a case of severe indigestion!). The mouth of a still-living long-horned sculpin protrudes from the maw of a recently sated sea raven. Despite being only slightly smaller, the sculpin was unable to escape during the time I was able to observe it.

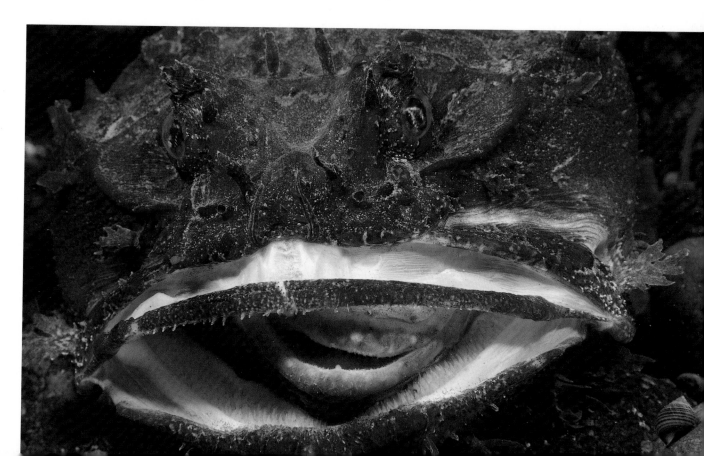

crustaceans wander over the stems and holdfasts (the claw-like base of the plant that grips onto the rocks) of the kelp.

I spot a lumpfish down in the kelp looking up at me with its big saucer eyes. The slow-moving, blunt-headed fish rises from the bottom and swims in a small circle over its precious patch of eggs, settling again once I've passed. In late spring, males, in their brilliant red breeding colour, use a specially evolved suction disk to attach themselves to the rocky bottom where they guard their eggs. The young

Below and facing page: Spectacular yellow and red sea ravens "fly" across the bottom, their pelvic fins spread like wings. This ambush predator has high colour variability and is common on the bottom of kelp beds where it will wait for unsuspecting prey to swim along before lunging with mouth agape.

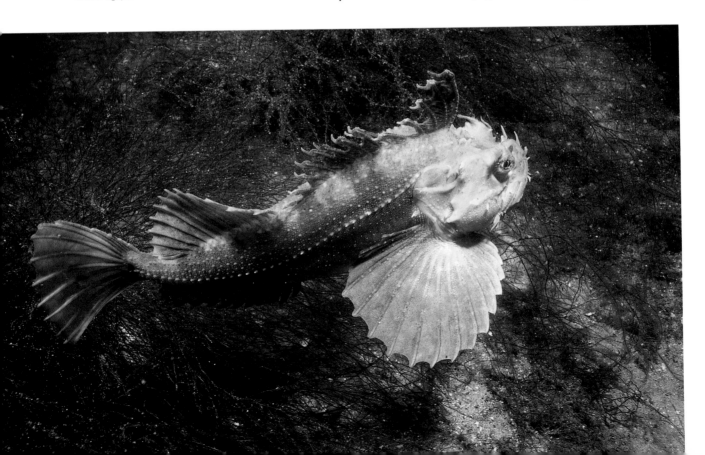

will hatch and eventually use their own disks to anchor themselves to the safety of a kelp frond to hide from predators and to rest. These endearing denizens of the sea propel themselves through the water by fluttering their pectoral fins and rather small tails, moving slowly and deliberately over the bottom, Tai Chi masters of the sea.

On a nearby sand patch between the boulders, hermit crabs ignore my looming shadow and the din of my bubbles. They seem to populate every square metre of sand, scuffling it up with their claws and feet, then filtering the nutritious

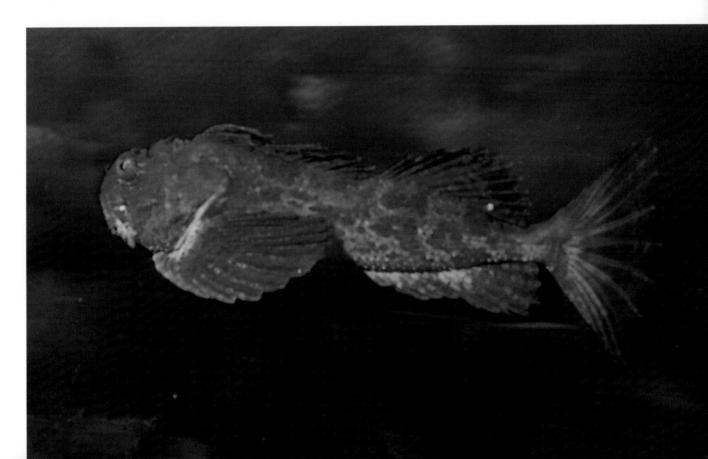

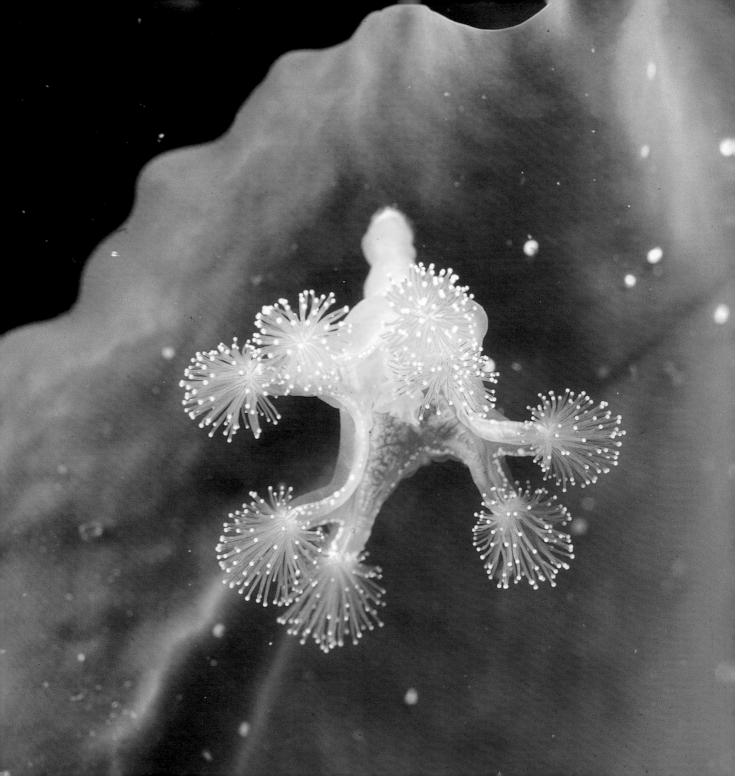

Left: Looking like an oddly shaped anemone, the 5-centimetre-tall trumpet-stalked jellyfish anchors itself to a frond of kelp where it captures small invertebrate prey.

Below: This small sculpin's colouration is superbly adapted to the pink coralline algae-encrusted rock that surrounds it.

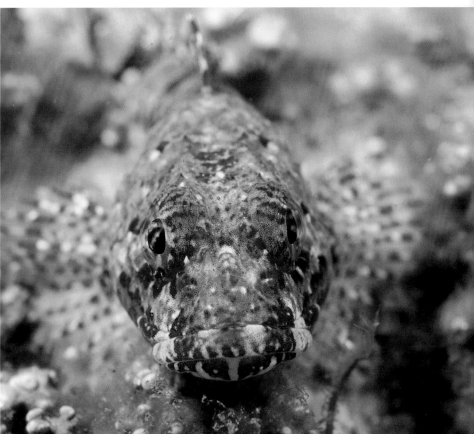

Below: This spectacular male lumpfish has attached itself to a frond of broad-leafed kelp with a special suction disk located on its belly.

Right: This winter skate, passing through boulders in a Bay of Fundy kelp bed, has bones of cartilage like a shark. Skates lay eggs in rectangular, horned cases known as "mermaid's purses." The young in the eggs are very slow to develop, not hatching until ten to twelve months have passed.

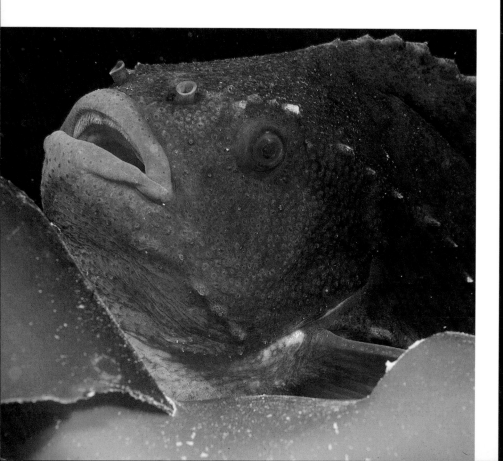

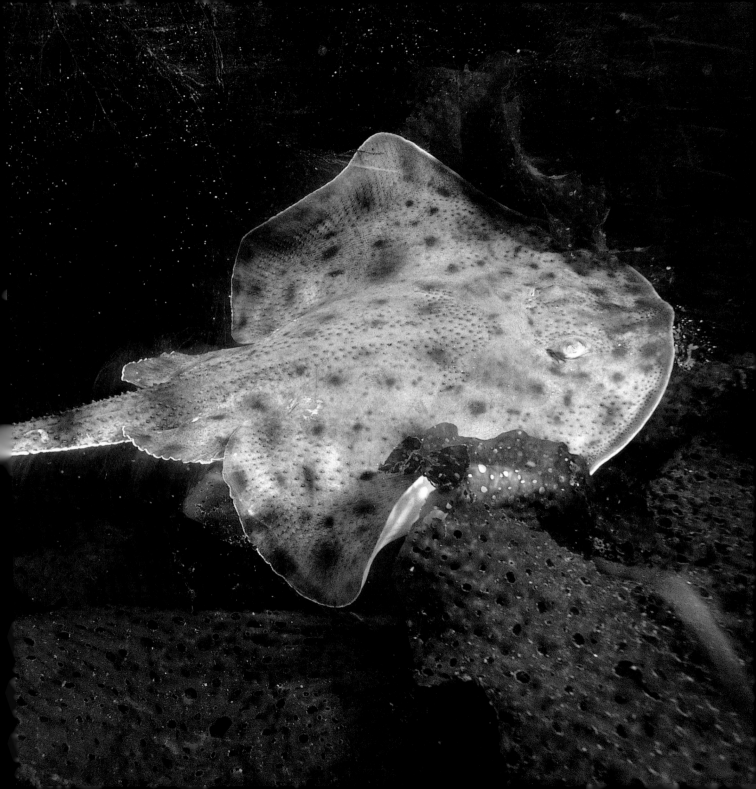

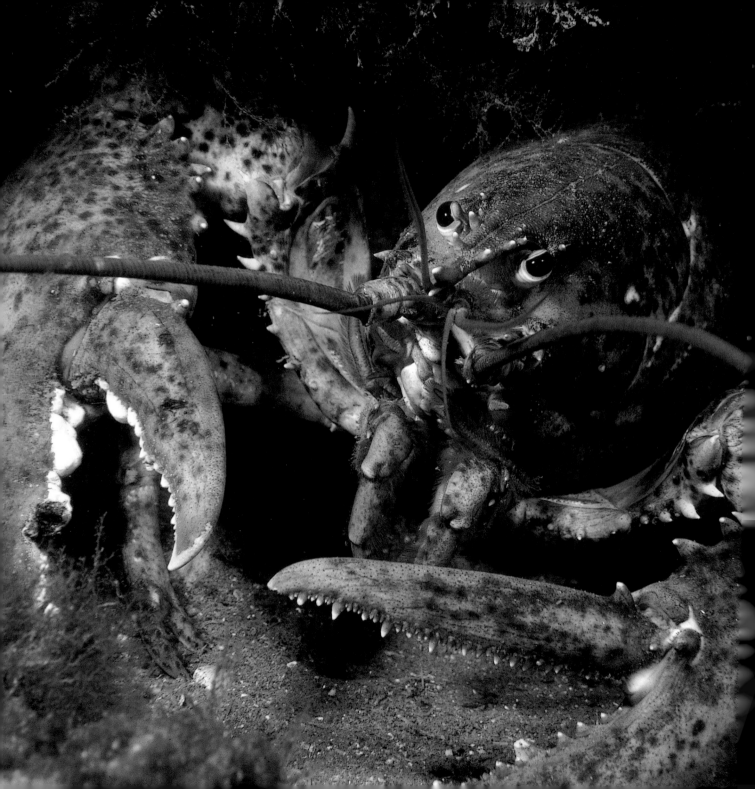

morsels that they need to sustain themselves from the silty water. These crustaceans, famous for carrying their mollusc-built homes on their backs, are comical creatures, and no exploration would seem complete without them. A dozen hermit crabs scuttle in every direction, making way for a large lobster that lumbers toward me across the sand. True to the optical physics of diving, where things viewed under water appear 25 percent bigger and closer than they do topside, this lobster looks gigantic as it draws near, but it isn't the largest one I've ever seen. That one had

Facing page: A large northern lobster emerges from beneath a rock near Deer Island where it is taking shelter from the running tide. The sluggish creature we see in restaurant tanks belies the quick and energetic nature of the lobster in its natural environment.

Below: The striking colours of a healthy, mature lobster are evident in this photo of one crawling across the bottom of a Brier Island kelp forest. The single most economically and ecologically important species here, lobster populations remain relatively healthy in the Bay of Fundy.

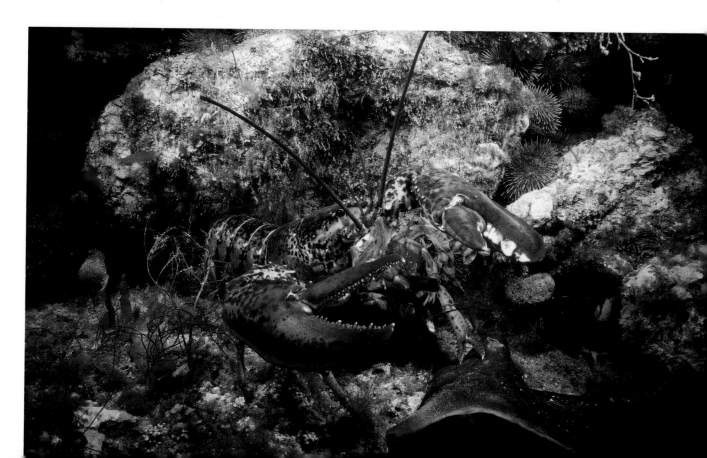

Facing page: A school of sand lance zooms over a sandy patch between knotted wrack and other vegetation at the shallow edge of a kelp bed in St. Mary's Bay, an arm of the extreme lower Bay of Fundy.

excavated a home in the gravel beneath a huge concrete block anchoring a large bell buoy. Its claws were the length of my elbow to my fingertips! I also know that the larger a lobster is, the more pugnacious it will be and the one I'm encountering now fits that notion perfectly. Unlike many marine animals, which get out of your way, I have to get out of its way as it crawls towards me over the sand with the sureness of a bulldozer. Of all the species that depend on the kelp forest, none is more important to humans than the northern lobster.

Below: The beautiful complexity of this lobster's antennae, eyes, and head region is apparent in this close-up.

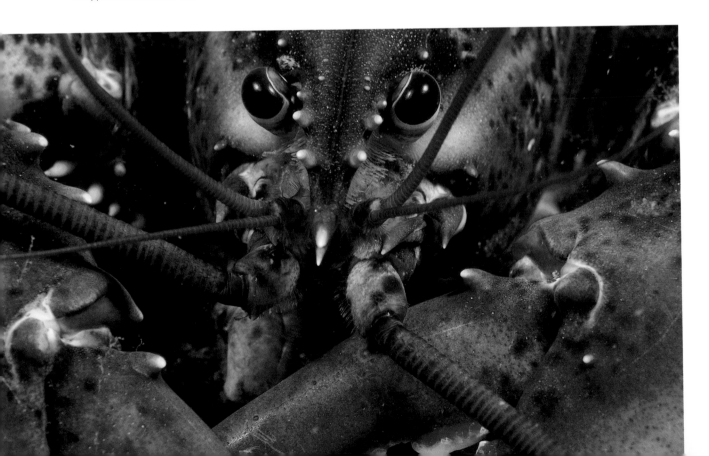

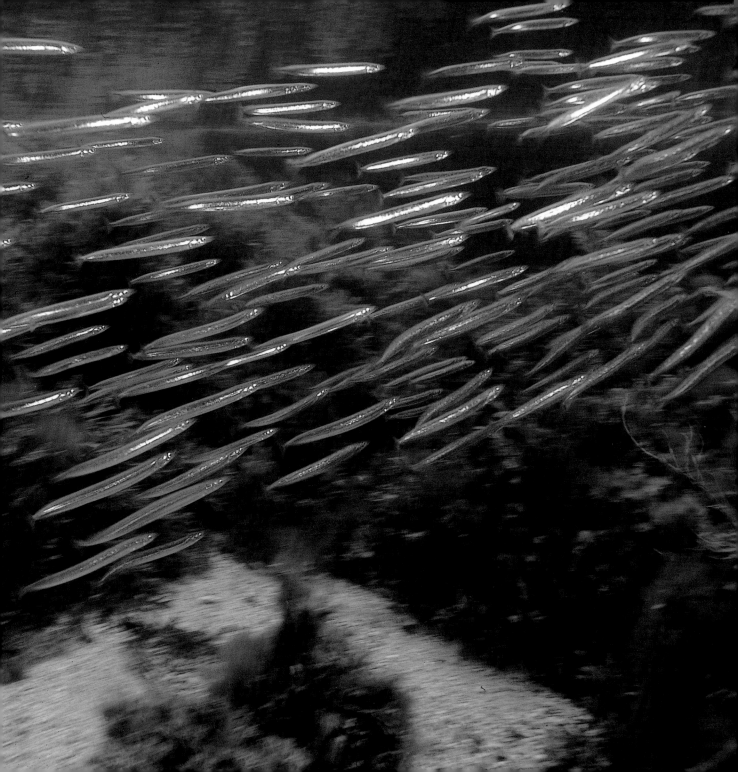

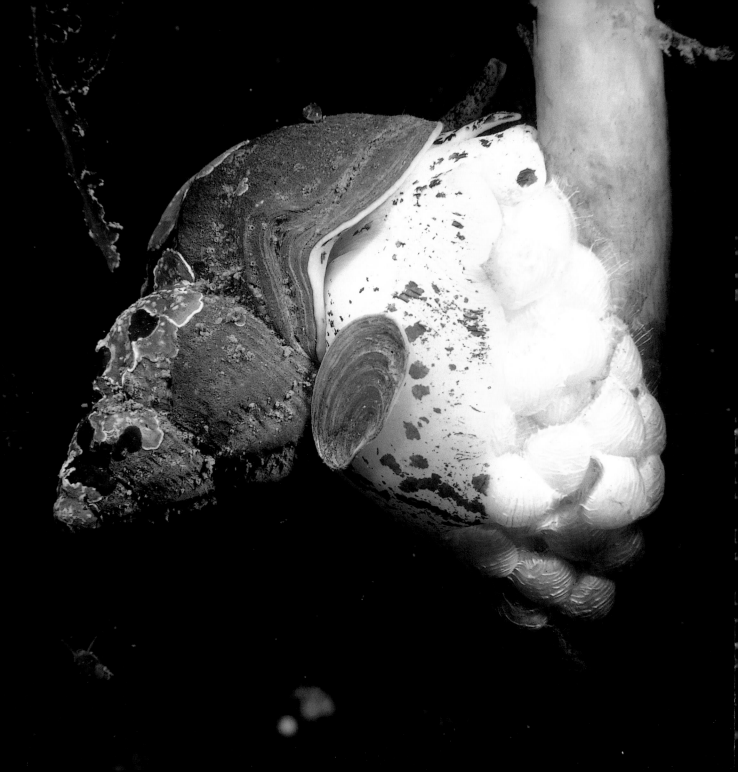

Facing page: A marine snail known as a waved whelk tends a mass of its eggs on a kelp stem. Whelks are scavengers and will eat anything from lobster bait found in traps to dead fish and invertebrates.

Below: This orange-footed sea cucumber is "licking its fingers," so to speak, as it inserts and then removes, in order, each of its tentacles from its mouth opening to remove tiny bits of food it has gleaned from the water.

Facing page: Taking advantage of this hermit crab's habit of stirring up the bottom gravel and sand between the kelp as it feeds, a colony of barnacles has taken up residence on its shell. Although it's possible that the barnacles already lived on the discarded snail shell when the crab moved in, the food particles stirred into the water by the crab must be a boon to them.

Below: Several sea lice have parasitized this small blue lumpfish in a winter kelp forest. Lumpfish are highly dependent on kelp for shelter, protection from predators, and as a place to lay eggs.

The lobster fishery is the largest sector in the fishing industry in the Bay of Fundy, producing tens of millions of dollars annually in revenue. The health of this key industry depends on the reproductive success of the species. Kelp beds are a vital habitat for young lobster. The sheltering nature of the kelp growth insulates the benthic zone (the sea bottom) from currents and waves. Species like the lumpfish, which lay fragile eggs, or those whose young are vulnerable to predation, such as the lobster, depend on the kelp bed as a sheltered nursery, where their offspring

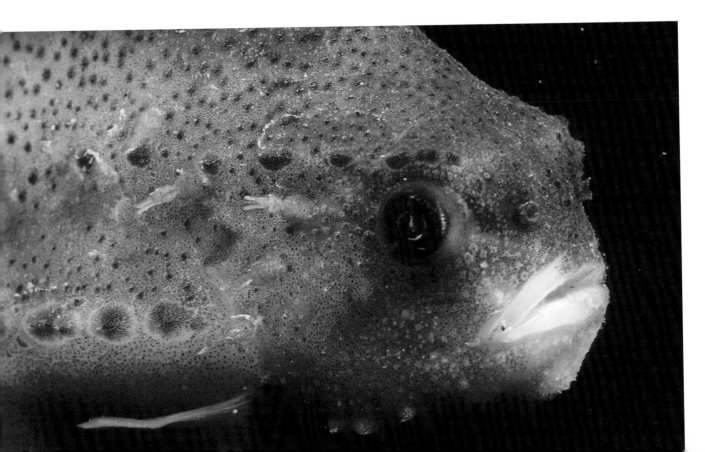

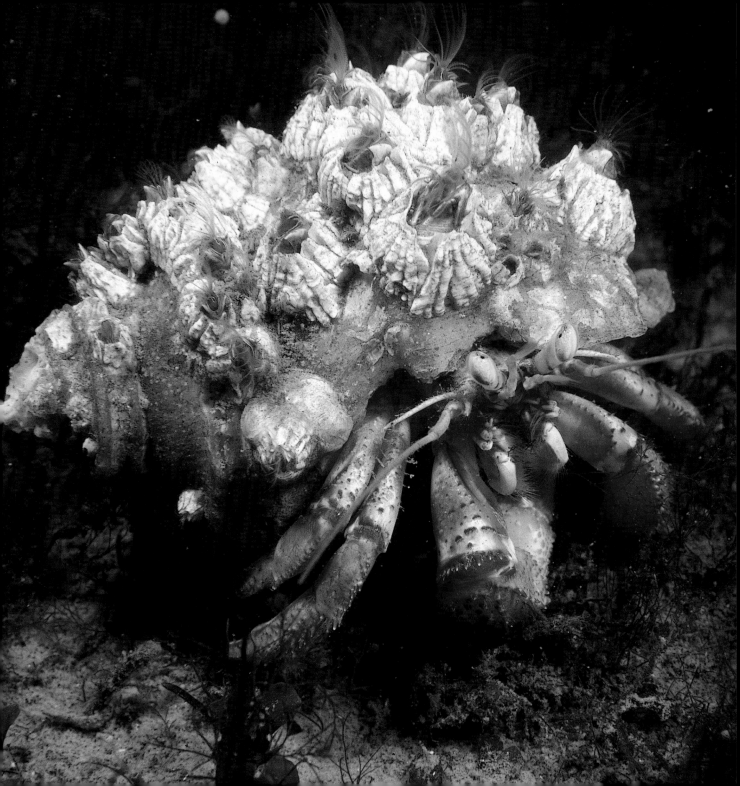

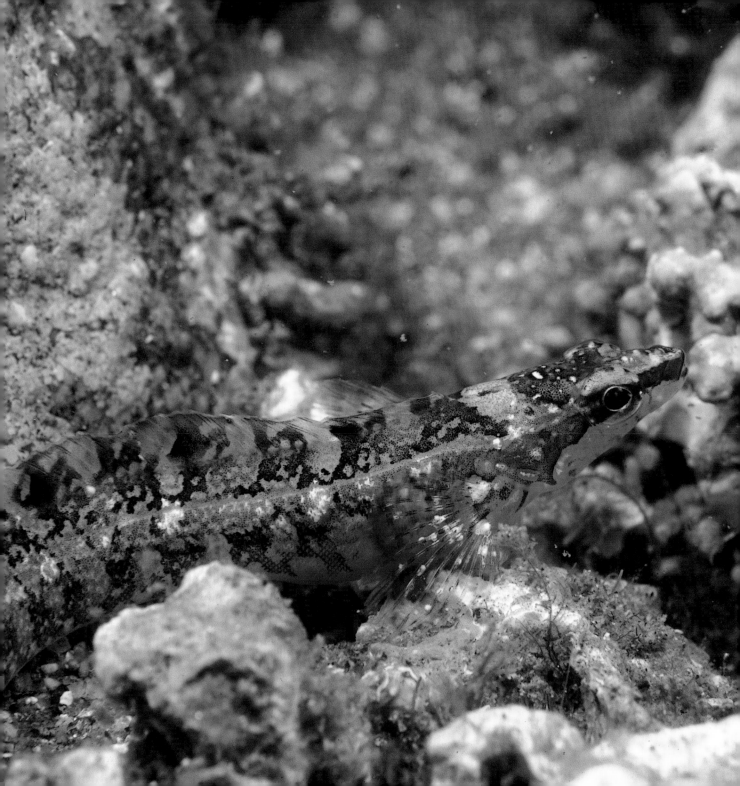

will have a better chance of surviving to maturity. After they are a month old or so, tiny larval lobsters give up the planktonic lifestyle of drifting aimlessly in mid-water, many of them eventually settling to the kelp forest floor to become bottom dwellers. Here, they coexist with other benthic organisms in the Bay of Fundy such as sea stars, sea urchins, crabs, mussels, and fish such as sculpins, gunnels, and flounder. They find critical hiding spaces among the cobble gravel, rocks, reef crevices, and vegetation in the kelp bed. With its population here still relatively healthy despite

Facing page: This Arctic shanny, a bottom dweller in relatively shallow water, abounds in kelp beds where abundant crevices are available to hide from predators such as cod, ocean pout, sculpins, and diving seabirds such as guillemots.

Below: A school of young pollock glide over a shallow kelp bed.

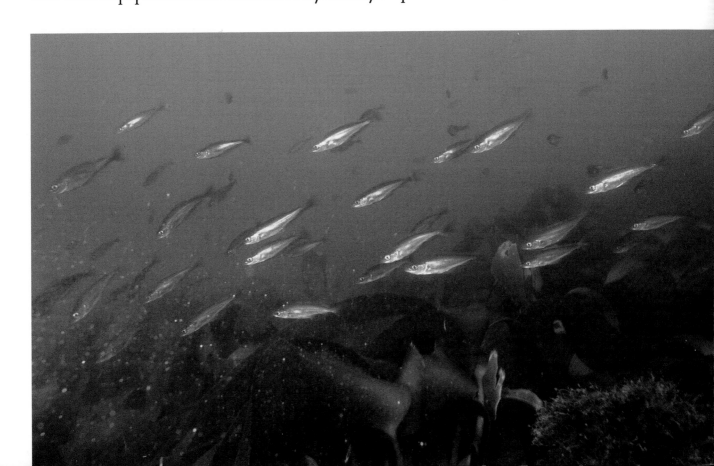

a vigorous, large-scale fishery, the feisty crustacean may have benefited from the collapse of groundfish species, such as cod, which prey upon very young lobsters.

In deeper water a flash of silver catches my eye. A small school of herring with a harbour seal in hot pursuit bolts into the open from the dimness of the understorey, coalesces into a dense ball, then disappears into the murky distance. This drama of predator and prey is one that must surely occur thousands of times a day throughout the bay.

I've rarely seen herring for more than an instant underwater. They are sensitive to the noise of a diver's bubbles and usually steer clear well before coming into view. Like the lobster, the Atlantic herring is an important part of the Bay of Fundy's ecosystem. Though its numbers have been drastically reduced by overfishing, it remains one of the most important fish in the bay. A vital link in the overall ecological web, herring provide a sizeable percentage of the food eaten by larger fish, porpoises, seals, and

A short-horn sculpin rests on the rocky bottom. Voracious eaters, they will consume almost anything, from the offal discarded by fish plants, to young cod, small lobster, crabs, and other invertebrates.

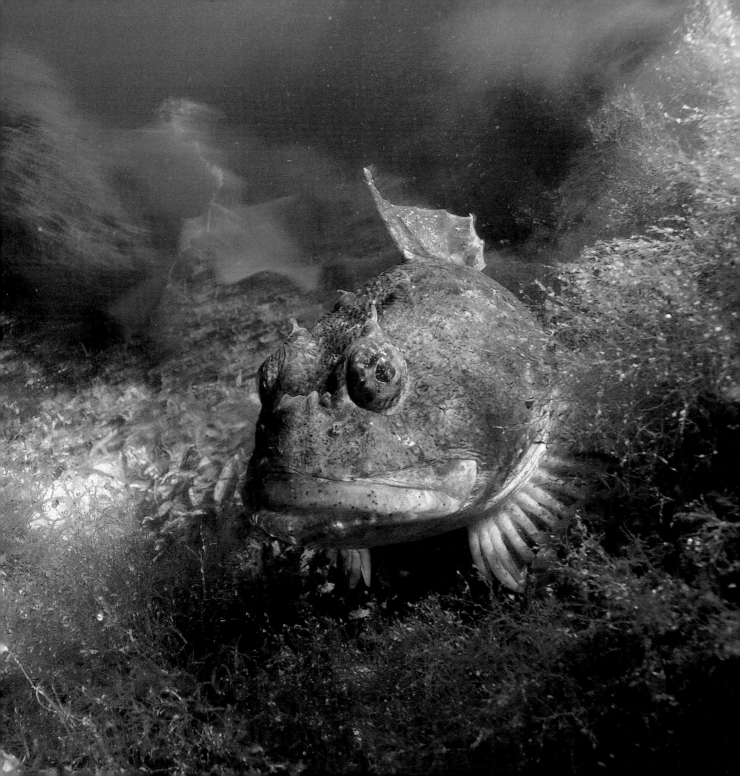

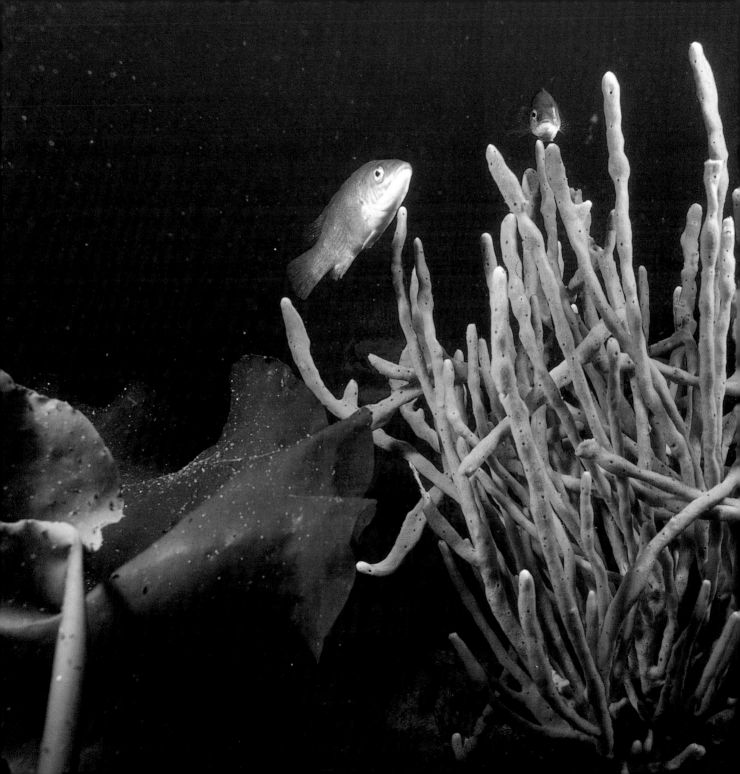

whales such as humpbacks. As with lobsters, kelp beds are important habitats for the reproductive success of herring. The stems and holdfasts of kelp, as well as the rocks and sand, can be literally blanketed with millions of tiny, fragile eggs after a school spawns. The Atlantic herring's reproduction has depended on healthy kelp ecosystems for thousands of years. It's just one of many natural relationships that highlight how important this habitat is for the overall health of the bay.

In 25 metres of water at the mouth of the cove, thousands of sea urchins cover the bare rock at the seaward edge of the kelp as far as I can see. One of the most dramatic boom-and-bust cycles in the ocean involves kelp and green sea urchins. Before these urchins arrived a few months ago, what is now bare rock was covered by a luxuriant growth of kelp. Hordes of them devoured the vegetation, leaving barrens in their wake. However, this urchin population will soon crash, after eating itself out of a food supply. Then the kelp will come back and the cycle will begin again. Helping to speed up this cycle in many places is the

A large finger sponge, with a couple of small cunners keeping it company, thrives in the strong current at the seaward edge of a Fundy kelp bed. It gets food by filtering it from the moving water.

commercial sea urchin diving fishery, which, by removing the urchins for their roe (sold as *uni* in Japanese restaurants), enables the kelp beds to regenerate more quickly. In an interesting twist that illustrates the interconnectedness of life in a marine ecosystem, including human life, some scientists believe the abundance of hiding places for young lobsters created in newly regenerating kelp beds that have been recently harvested of urchins may increase the lobster's rate of survival.

The bottom slopes gently seaward beyond the urchins. Outside the protected cove, the tide is running. The dense kelp has given way to a relatively featureless plain with scattered rocks and the occasional boulder. Shelter-loving species of the kelp forest are replaced by mud and sand bottom specialists such as orange-footed sea cucumbers, moon snails, squirrel hake, and skates. My depth gauge reads 40 metres. This is below the point at which sunlight-dependent plants such as kelp readily grow. At this depth the most conspicuous living things on the sea floor are sponges, specifically eyed-finger sponges, which resemble large hands reaching upward. One of the most primitive of all animals, they grow on larger boulders and filter tiny food particles from the water. Beyond here, in water too deep for normal scuba diving, lie thousands of square kilometres of unexplored sea floor that account for most

of the Bay of Fundy's area.

Nearly out of air and my decompression time limit fast approaching, it's time to finish this exploration of a Bay of Fundy kelp forest. I swim back toward the cove and into the kelp in shallower water. A brilliant-red sea raven swims across the bottom in the same direction, as if escorting me to the shore. I begin my ascent as it disappears into the forest.

The short-horn sculpin can grow very large by sculpin standards and may reach up to over half a metre long. Though the wide-angle perspective of this image exaggerates the size of nearer fish, the size of the lobster in the background gives a good sense of its large scale.

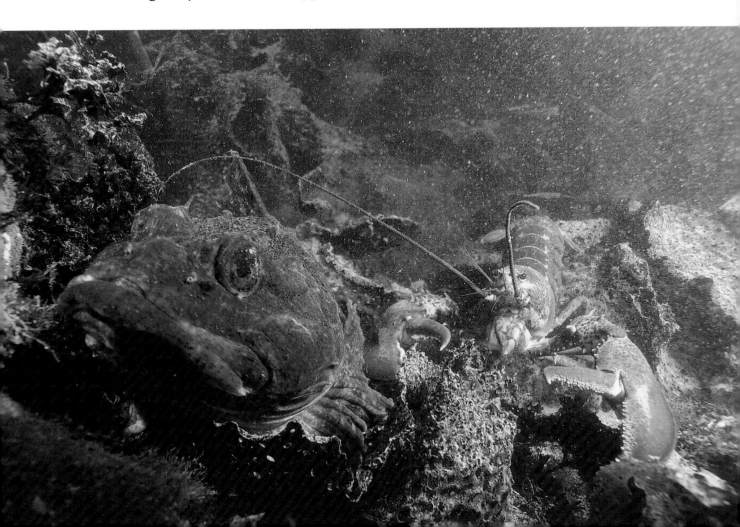

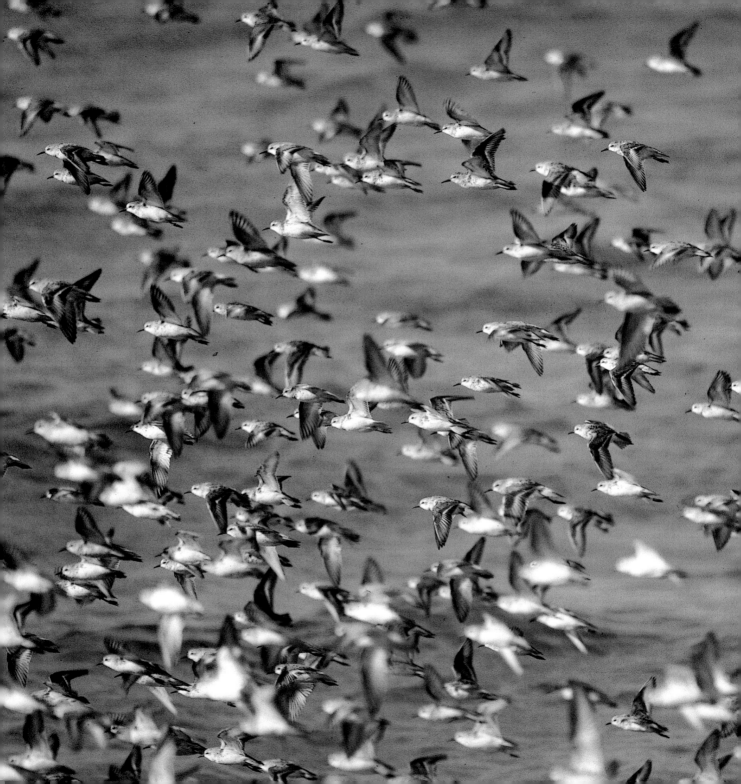

CHAPTER 4

A Celebration of Wings:
Shorebirds and Seabirds of the Bay of Fundy

ON A LATE JUNE EVENING, FROM ATOP CAPE BLOMIDON, a 170-metre-high headland jutting into Minas Basin in the upper Bay of Fundy, I look out on mile after mile of reddish-brown mud stretching to the horizon at low tide. At first blush, these vast tidal flats at the head of the bay appear virtually lifeless. But a population explosion is happening in all that gooey, boot-sucking muck. Rice-grain-sized Fundy mud shrimp, also known as *Corophium* shrimp are in the middle of a reproductive bonanza that will peak at 20,000 animals per square metre. Multiply *that* by all the muddy real estate here and the astronomical abundance of these animals becomes apparent.

In mid-July, just as mud shrimp numbers skyrocket into the billions, something incredible happens. One of

Facing page: An enormous flock of semi-palmated sandpipers flies above the water in New Brunswick's Chignecto Bay during fall migration. Such flocks of thousands on the wing are not uncommon.

the continent's great natural dramas unfolds. Drawn by this ready smorgasbord, wave after wave of between 2 and 3 *million* southward migrating shorebirds from all over the Arctic and the Subarctic converge on the upper bay's mud flats, beaches, and surrounding salt marshes. The site of the world's highest tides is transformed into "shorebird central." Some thirty species of shorebirds, including greater and lesser yellowlegs, black-bellied and semipalmated plovers, dunlins, ruddy turnstones, dowitchers, and several species of sandpipers, stop by. Remarkably,

Bald eagles are the largest bird of prey found near the estuaries that drain into the Bay of Fundy. They are quite common throughout the region, where they nest near water, both salt and fresh.

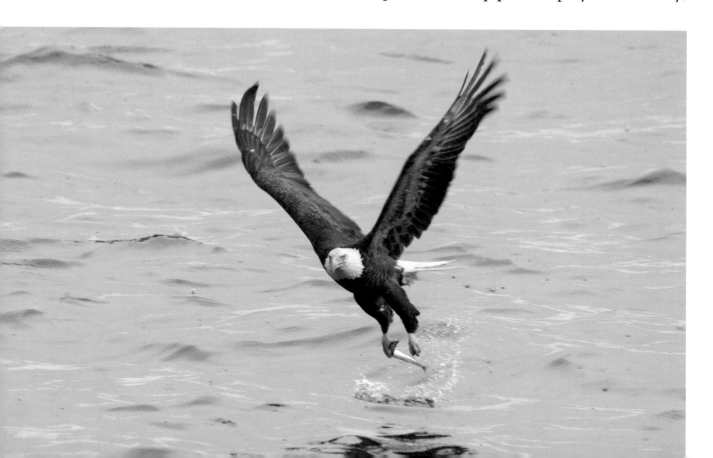

up to 90 percent of the continent's population of semi-palmated sandpipers (whose numbers account for well over four-fifths of all the shorebirds here) stop over to fuel up for their long southerly journey.

Dispersing over the expansive tidal flats, the birds pick shrimp from the mud as the tide goes out, following the edge of the receding water until they are barely visible from the beach. Eventually, they'll begin moving back toward the shore, keeping ahead of the rising tide by running and flying. Gigantic flocks of a quarter of a

This black-bellied plover (here in its plain, non-breeding plumage) stretches while resting on a mud flat. This largest of the plover family is the most numerous bird found in the upper bay during spring migration.

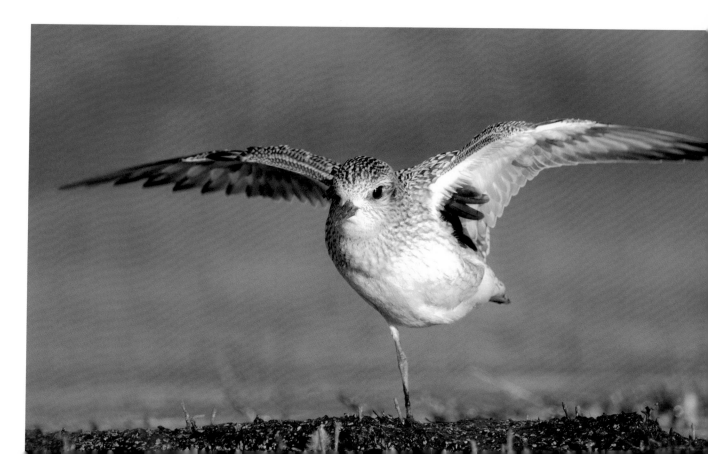

Far less common than their larger cousins, the Canada geese, two Brant geese fly over Brier Island in the lower bay. Although they do not breed in the Bay of Fundy, a small group of birds has perennially overwintered around Brier Island and Grand Manan. Small flocks of 100 or so birds stop by Minas Basin during spring migration.

million semi-palmated sandpipers have been reported and it's not unusual to see thousands of birds moving through the sky in perfect unison, sometimes covering the Sun like a cloud. When the mud is completely covered by water and nothing remains but a thin line of sand high on the shore, the birds are crowded closer and closer together by the advancing water.

Thousands of sandpipers and plovers jostle with each other to find a resting place on the narrow beaches. They are soon crowded shoulder to shoulder, and bill to rump

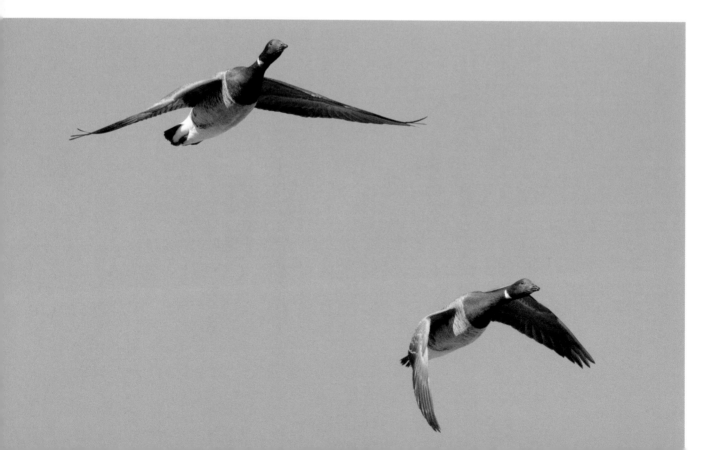

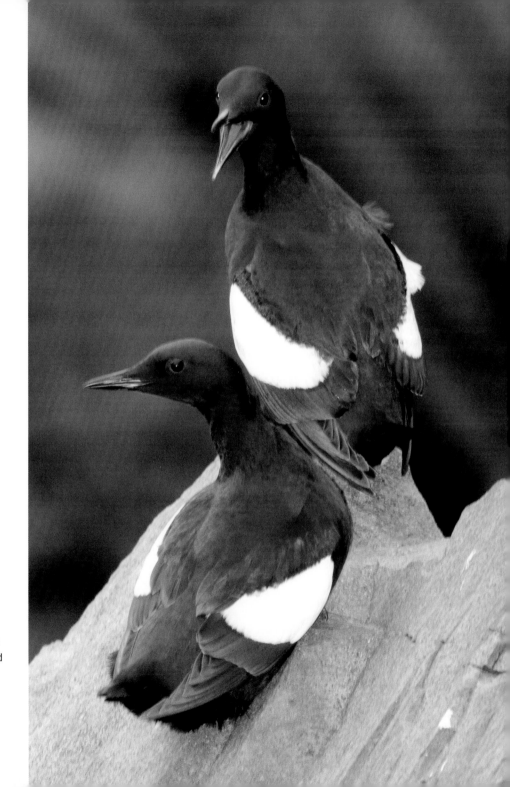

Black guillemots, commonly known as sea pigeons, breed in small numbers throughout the Bay of Fundy on cliffs and islands. Many more birds, from large breeding colonies around the Gulf of St. Lawrence and Newfoundland, as well as from Cape Breton Island, overwinter in the Bay of Fundy due to its ice-free nature and abundance of food.

Facing page: A raft of common eider duck drifts in the tidal current between Long and Brier islands. The hemisphere's largest species of duck, eiders hunt by diving up to 20 metres deep to gather mussels, sea urchins, and other marine life.

Below: A common tern heads home with a freshly caught sand lance in the lower Bay of Fundy. Along with less common Arctic terns, they nest on both the Nova Scotia and the New Brunswick sides of the bay.

on the sand, where they'll sleep for a while until the receding tide begins to lay bare the shrimp-rich mud flats, prompting the feeding cycle to begin again.

In a process called hyperphagia (scientific parlance for gluttony), the semi-palmated sandpipers fatten up quickly on the mud shrimp, eating more than 10,000 of them a day and doubling their body weight in the two to three weeks the average bird stays. Then, in a feat of avian athleticism, not to mention navigational prowess that would have astonished Magellan, the 30-gram birds

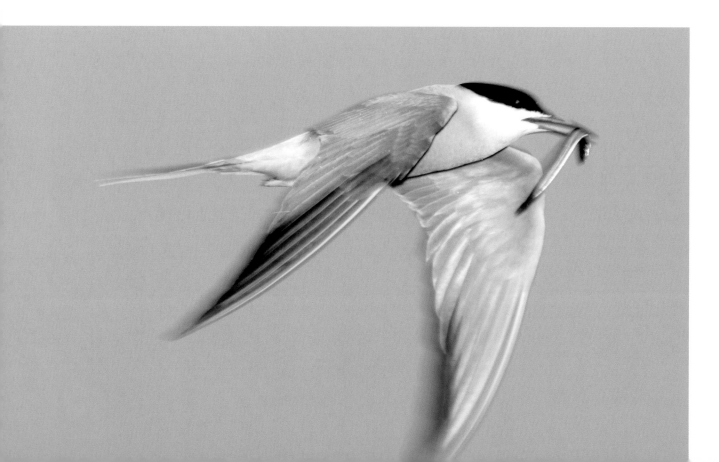

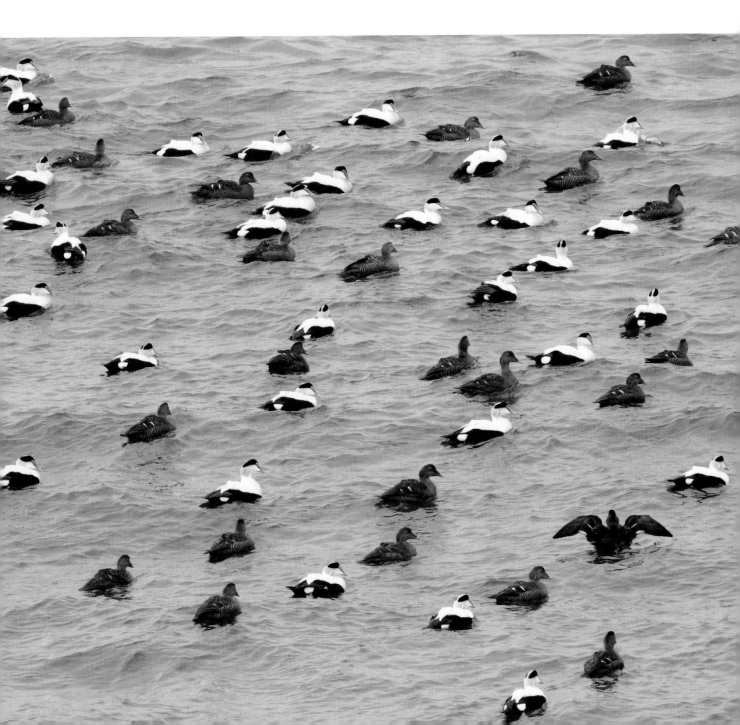

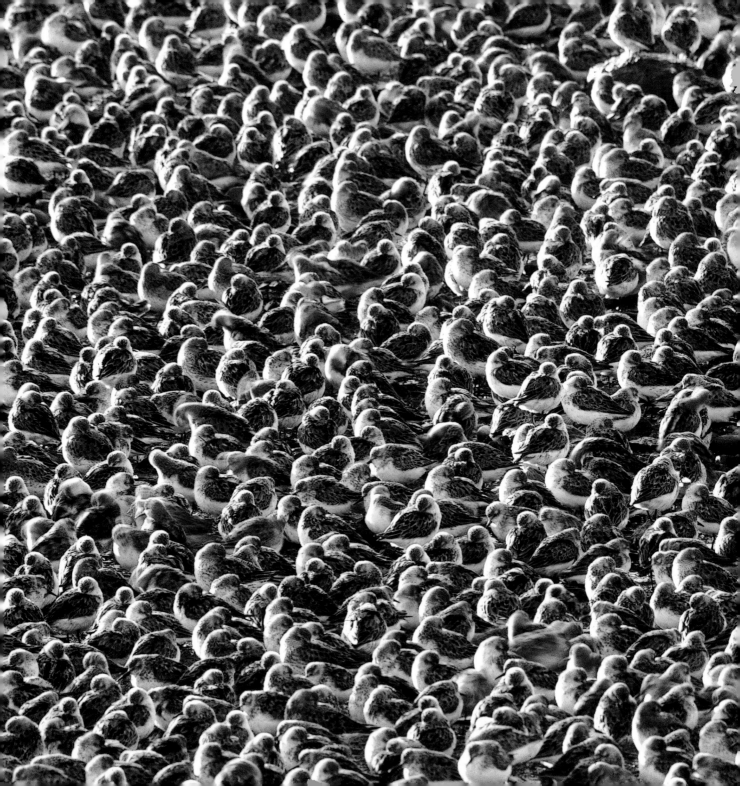

embark on a non-stop seventy-two-hour flight of 4,500 kilometres over the Atlantic to the northern coast of South America. Without the abundant nutrition provided by the Fundy mud shrimp, this epic journey would be impossible. Once on the South American coast, the emaciated, nearly exhausted birds will feed briefly to stock up energy for the final 2,500-kilometre leg of their journey to northern Chile and southern Brazil.

In recognition of its global importance for shorebird populations, parts of the upper Bay of Fundy have been designated as a "Hemispheric Shorebird Reserve" by the Western Hemisphere Shorebird Reserve Network. Few places, so small in area, are of such vital importance to so many birds, a fact that emphasizes the vulnerability of these migrant shorebirds and their habitats.

All may not be well in the upper Bay of Fundy ecosystem. Scientists have noticed an apparent decline in recent years in the number of birds stopping over. They suggest the population of mud shrimp may be declining, which would naturally affect the migrants. In some areas once brimming with the crustaceans, the mud has become soupy in places and sandy in others, making for poor shrimp habitat. Reasons for the change are unclear, but rising sea levels from global warming and altered siltation patterns caused by the damming in the 1960s and 1970s

Facing page: The receding tide before sun-up draws semi-palmated sandpipers by the thousands in search of the abundant Fundy mud shrimp.

of many of the rivers emptying into the upper bay may be the culprits. For example, a causeway was built across the Avon River in Minas Basin several decades ago. Since then, a huge amount of mud has accumulated on the downstream side, creating a large grassy salt marsh where once the tide flats were. That took a lot of mud and this begs the question: Where would all the mud have naturally ended up before the causeway was built? Might the possibility that this mud didn't reach the places it historically did have a negative effect on mud shrimp habitat? What

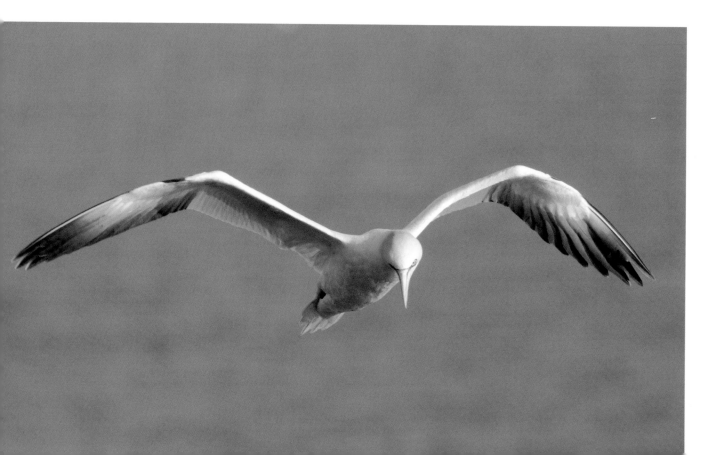

Using its highly acute vision, this gannet scans the water 30 metres below for signs of fish. Once one is spotted, it will plummet and plunge-dive into the water to capture its prey.

overall impact does the Avon River's and other dams have on the distribution of mud shrimp and shorebirds in the upper bay? Nobody knows for sure yet. The effect of rising sea levels and warmer water as a result of global warming on ecosystems is also unknown.

Another potential threat is the oil tanker traffic some 150 kilometres away in the lower Bay of Fundy. The catastrophe caused by a large oil slick reaching the mud flats of the upper bay can scarcely be imagined.

However, being disturbed by humans while they are

The Bay of Fundy is critical habitat for a variety of species that are threatened with extinction, such as these Harlequin ducks along the rocky shore of the lower bay. The entire population of the Harlequins in eastern North America is thought to number about 1500 or so, some of which winter in the Bay of Fundy. They are listed by the Canadian government as a "Species of Special Concern."

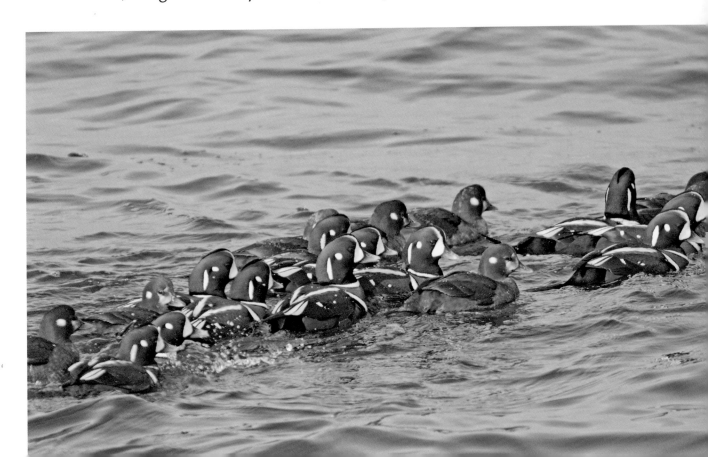

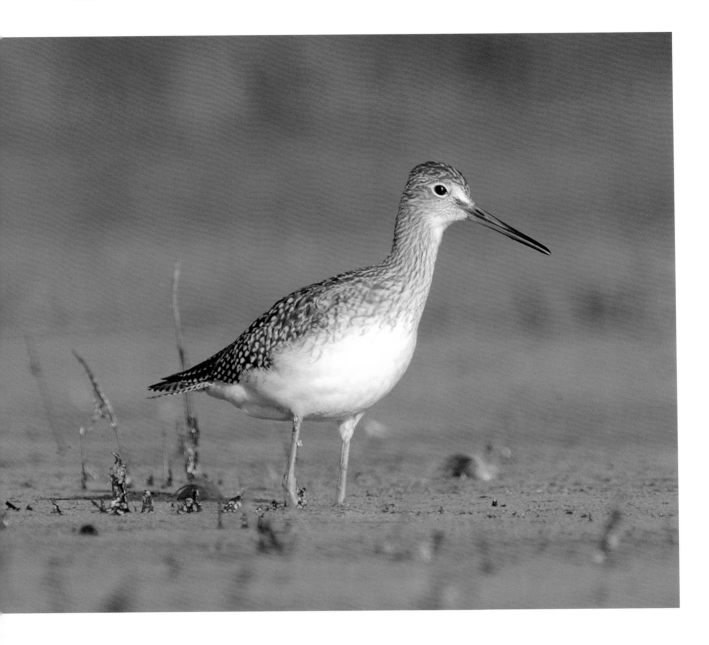

resting is the greatest immediate challenge to the birds' welfare during their stay in the Bay of Fundy. Each time they're unwittingly frightened into the air by someone approaching too closely on the beach, they burn up energy crucial for migrating. This remains a serious problem, but fortunately, on-site education at well-known roosting areas in recent years has helped reduce such disturbances, thus enabling the flocks to conserve energy before leaving on the longest, most arduous leg of their migration.

While Fundy shorebirds flock to the sheltered inlets

Facing page: A greater yellowlegs wading in a shallow marsh at the head of the Bay of Fundy, near Amherst Point. Both greater and lesser yellowlegs are common migrants along the shores of the bay.

Below: A great black-backed gull in flight over Grand Manan Island. Black-backs, though less common than the smaller herring gull, appear to be increasing in numbers in places, even though they rely less on human food sources than the herring gull.

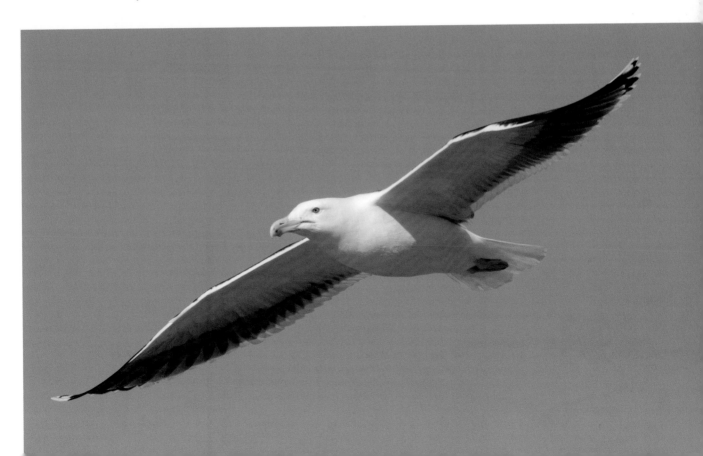

Below: This least sandpiper, the smallest sandpiper species in North America, rests on a mud flat in a freshwater marsh near Nova Scotia's Annapolis Basin, a semi-enclosed tidal inlet of the Bay of Fundy.

Right: The most ubiquitous year-round birds in the bay are herring gulls. Despite numbers that have increased over past decades as the amount of food in the form of human refuse has increased, the majority of herring gulls feed on wild prey such as fish and crustaceans.

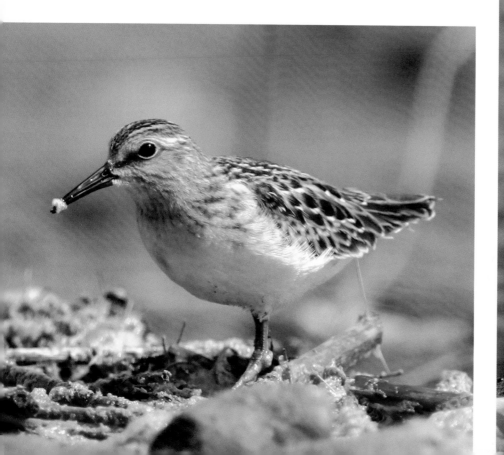

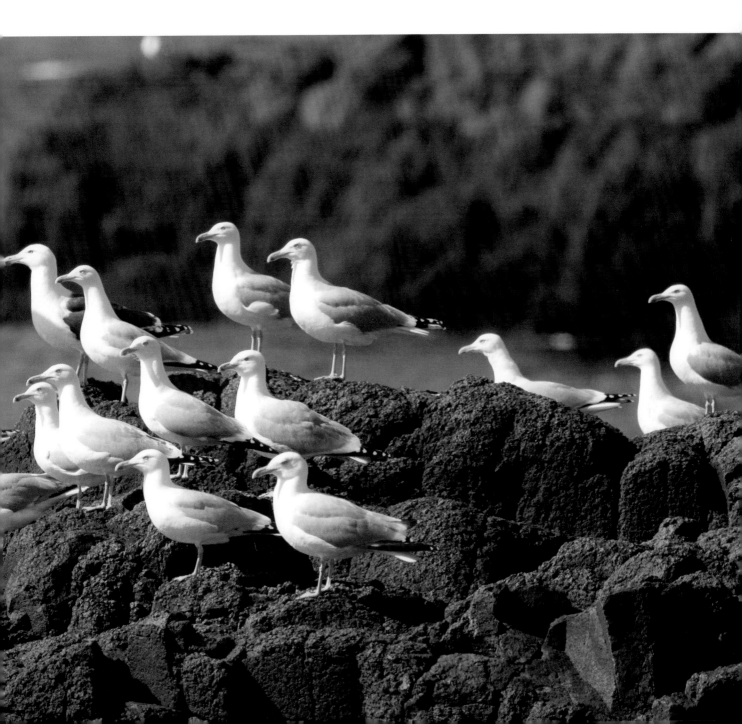

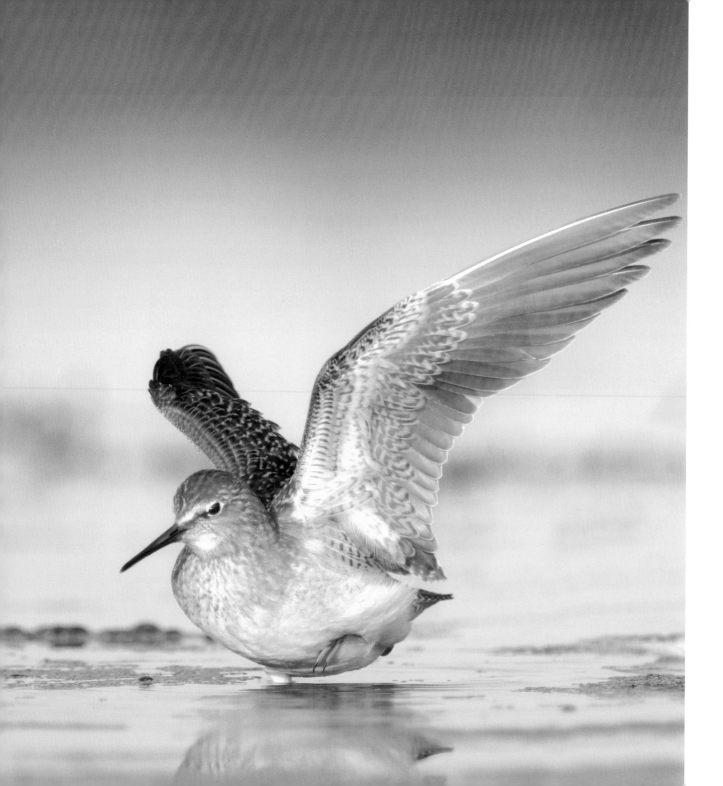

and basins of the upper bay, with its shallow water and rich mud flats, the realm of seabirds is in the lower bay, where the water is cold and deep. Here, the birds make their livings directly from the sea, where the table is set by the tide with a constantly renewed cornucopia of fish, crustaceans, and plankton. Several species of seabirds such as northern gannets, Atlantic puffins, razorbills, and black guillemots pass through the bay in great numbers during the late fall and, to a lesser extent, in the spring (puffins, guillemots, and razorbills actually breed in the

Facing page: This lesser yellowlegs stretches its wings in a salt marsh during fall migration.

Below: This osprey polishes off a fish it caught in Annapolis Basin, an important estuary on the Bay of Fundy. Ospreys nest all along the shores of Fundy, preying on the abundant fish available.

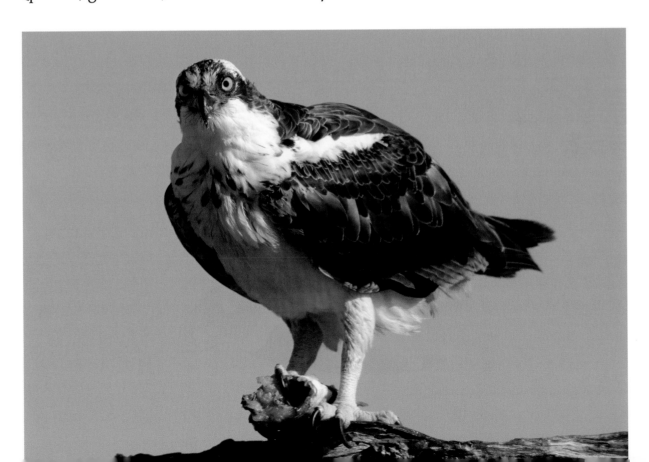

Facing page: A rather uncommon pectoral sandpiper struts along a mud flat as it looks for tiny marine worms and other invertebrates to feed on.

Below: Colourful clowns of the sea, puffins breed in relatively small numbers on Machias Seal Island south of Grand Manan, New Brunswick. Even larger numbers of puffins from Newfoundland and the Gulf of St. Lawrence turn up during migration in the fall when they visit the bay to feed.

bay in small numbers, as well). Here they will feed on the same kind of abundance that draws marine mammals.

Dozens of northern gannets wing their way over the tossing waves and lunging whitecaps of a late autumn storm. Some are at altitude in the distance, while others practically skim the surf along the shore. Despite an October gale strong enough to blow me off my feet, these large seabirds are completely at ease in their element. Finding a

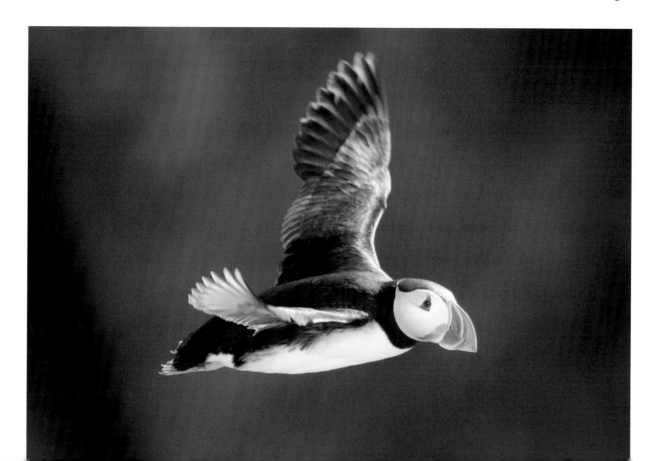

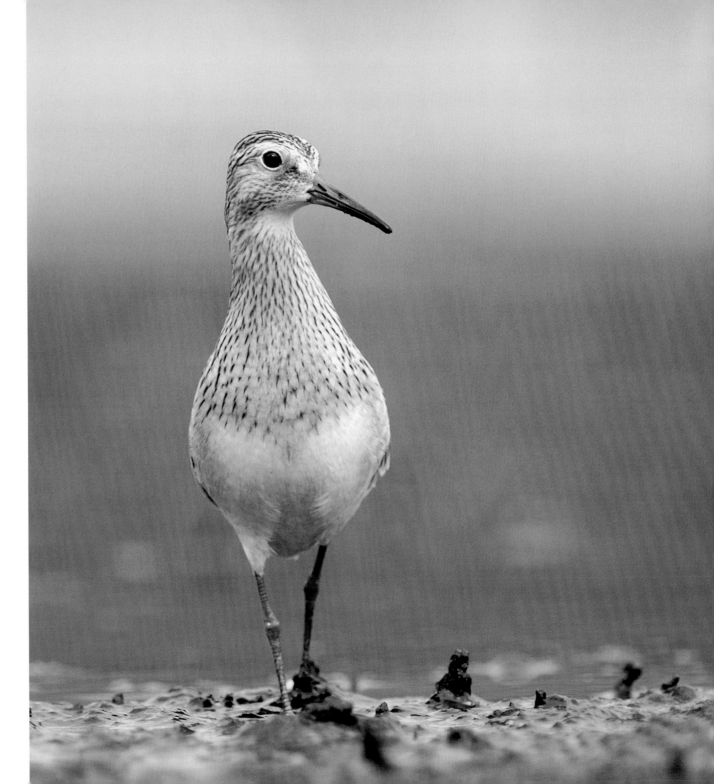

sheltered spot, I settle in to watch the breathtaking aerial ballet of the North Atlantic's largest seabird. Like the albatross of southern oceans, the gannet is an expert aviator that makes efficient use of the updrafts and air currents created as the wind interacts with the waves. On long, steady wings spanning 2 metres, they fly effortlessly in the roughest of conditions, using sharp binocular vision to scan the water below for fish. When prey is spotted, they go into action. Diving from a height of up to 30 metres, they enter the sea headfirst, extending their wings straight behind them just before impact, slicing into the water like javelins. Although gannets nested on two rocky islets in the bay up until the mid-1800s, (both aptly named Gannet Rock, one on the Nova Scotia side, one on the New Brunswick side), they no longer breed here. Those seen these days are migrants that breed in southeastern Newfoundland and the Gulf of St. Lawrence.

A little further along the shore, with the help of a spotting scope, I see the little black-and-white shapes of puffins bobbing about offshore in the biting northwesterly wind. Scattered groups of five or ten birds are dwarfed by the crashing whitecaps. They paddle over peaks and through troughs looking for small fish and invertebrates stirred to the surface, and seem to be oblivious to the tempest around them. Though the bay is home to a single

Facing page: This short-billed dowitcher, a common fall migrant in the Bay of Fundy, uses its long bill to probe for prey such as aquatic insects and worms, which are buried deep in the mud.

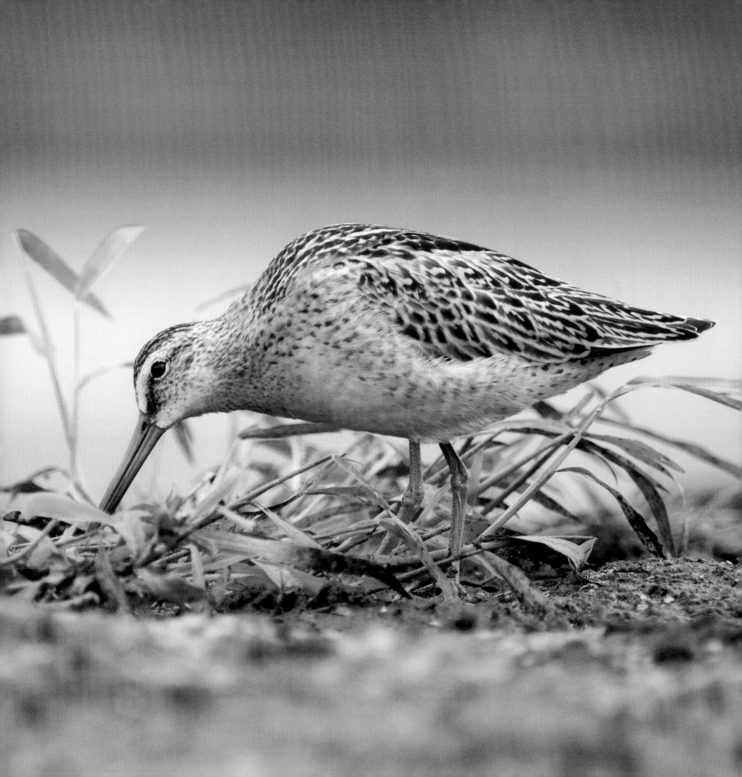

Facing page: A lone semi-palmated sandpiper stands in the late summer rain on a flooded field near Evangeline Beach, Nova Scotia.

Below: A fall migrant ruddy turnstone wades in shallow water as the tide comes in. It forages by flipping over small stones and grabbing worms and other invertebrates that live underneath.

breeding colony of some 1,000 pairs on Machias Seal Island off the southwestern New Brunswick coast the birds I see today are likely a few of the more numerous migrants from breeding sites around Newfoundland.

Puffins, gannets, murres, and other ocean-dwelling birds are exquisitely adapted to an incredibly hostile environment. They have no shelter from the harsh conditions that are found on the open ocean. Once they have finished their summer breeding season, they will not set foot on land again until the following spring. Seabirds

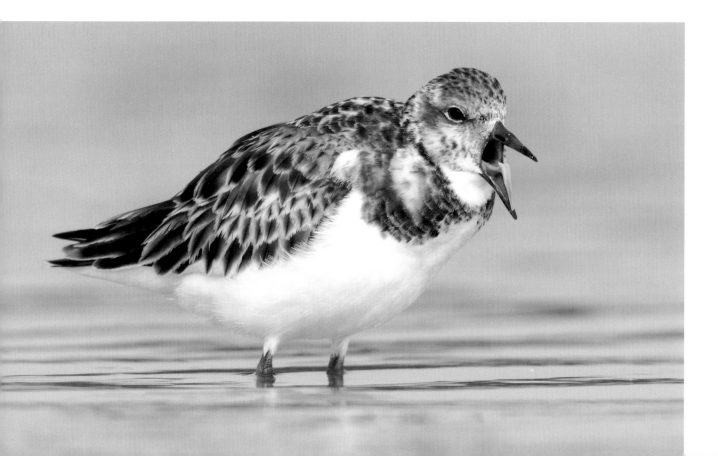

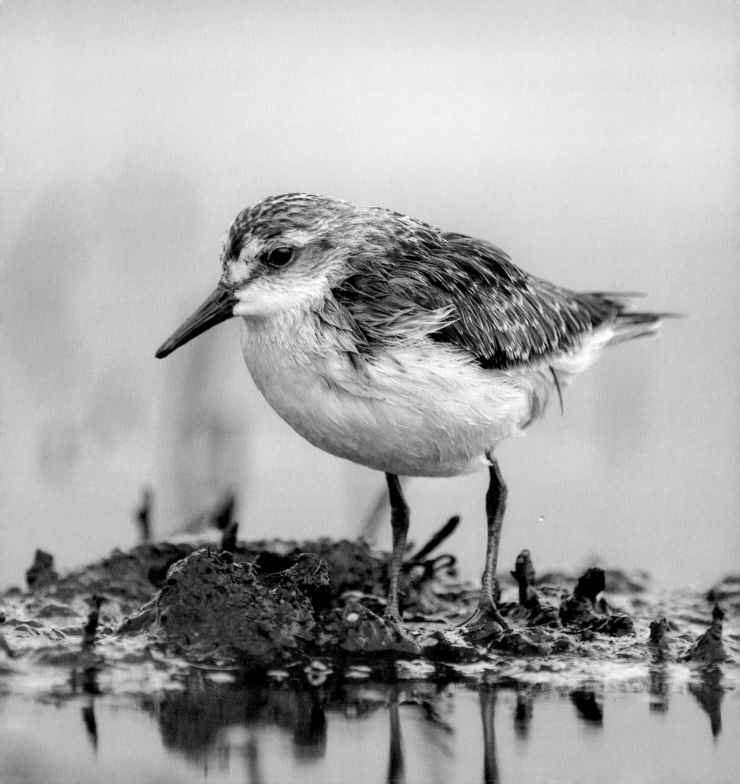

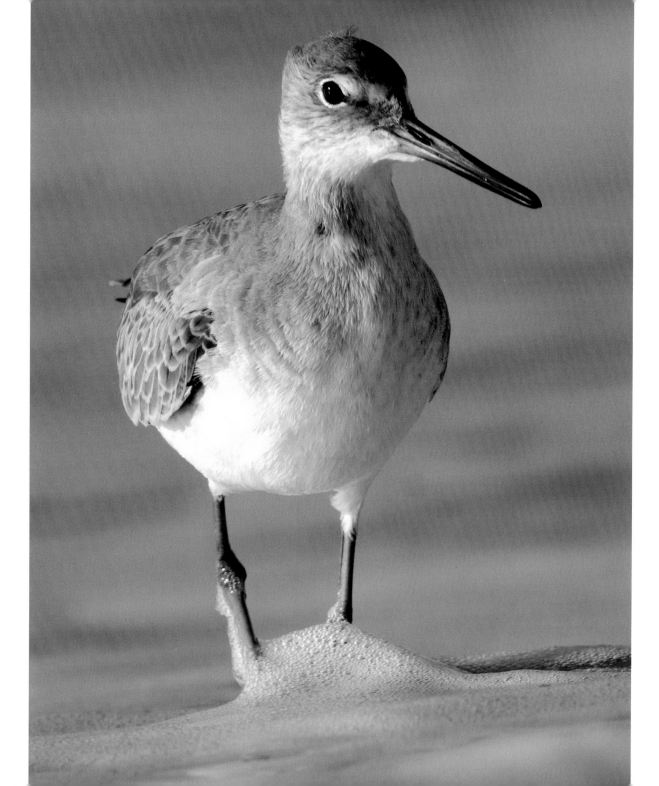

handle the adversities of wind, wave, and ice with aplomb, but not so the insults of reckless human behaviour. Because of the tragic overlap of seabird wintering grounds and international shipping lanes in the North Atlantic south of Newfoundland, some 300,000 seabirds *per year* are estimated to be killed by oil that is wantonly and illegally dumped from the bilges of passing ships. Although this occurs mostly outside the Bay of Fundy, these losses are felt here as the overall populations of these birds decline. That this largely unpublicized ecological disaster continues unabated is one of the tragedies of our time.

When the ebbing or flowing tide is squeezed into a narrow, shallow passage, the velocity of the water increases. As this happens, as it does around the islands of the Grand Manan and Deer Island archipelagos, or Long and Brier islands on the other side of the bay, it creates conditions that are ideal for birds that dive for their food.

Peter's Island is a small treeless lump of basalt located between Brier and Long islands in the lower Bay of Fundy. This rock in a tidal stream sits in the middle of the passage that separates the two larger islands. The tide flowing through Grand Passage is forced into two narrow channels as it skirts the island, creating a violent 6-knot current and

Facing page: This willet is wading along the surf line of a Bay of Fundy beach. They are quite common breeders, building their nests in woods and thickets near salt marshes of the bay.

a maelstrom of eddies, rips, and whirlpools. Even more, treacherous standing waves form when a strong wind is blowing against the current.

Surrounding our small skiff are rafts of common eiders, the northern hemisphere's biggest duck. They swim in formation in the larger eddies and along tide lines. Here, they dive as deep as 20 metres to the rocky bottom to feed on the blue mussels and green sea urchins that thrive in the strong currents. Famous as the source of eiderdown, this once very abundant bird's numbers continue to decline, largely as the result of overhunting and pollution. Fortunately, these spectacular animals—the males are a striking black and white—are still common enough to be easily observed around many Bay of Fundy islands.

As we approach Peter's Island in a small skiff, the hundreds of common and Arctic terns that nest there become aware of our presence and their grating cries fill the air. To avoid disturbing the birds too much, we don't put ashore. If the birds abandon their eggs even for a short time, they could become addled in the hot Sun.

Terns are among the most graceful flyers in the avian world. Incredibly buoyant in the air, each down-stroke of their wings lofts their bodies upward as if to defy gravity. A flock swarms over the island beneath the vaulting blue sky. Some aggressively dive at us, while others plunge into

Facing page: This Wilson's snipe is foraging in the shallow water of a freshwater marsh in Shepody Wildlife Area, New Brunswick.

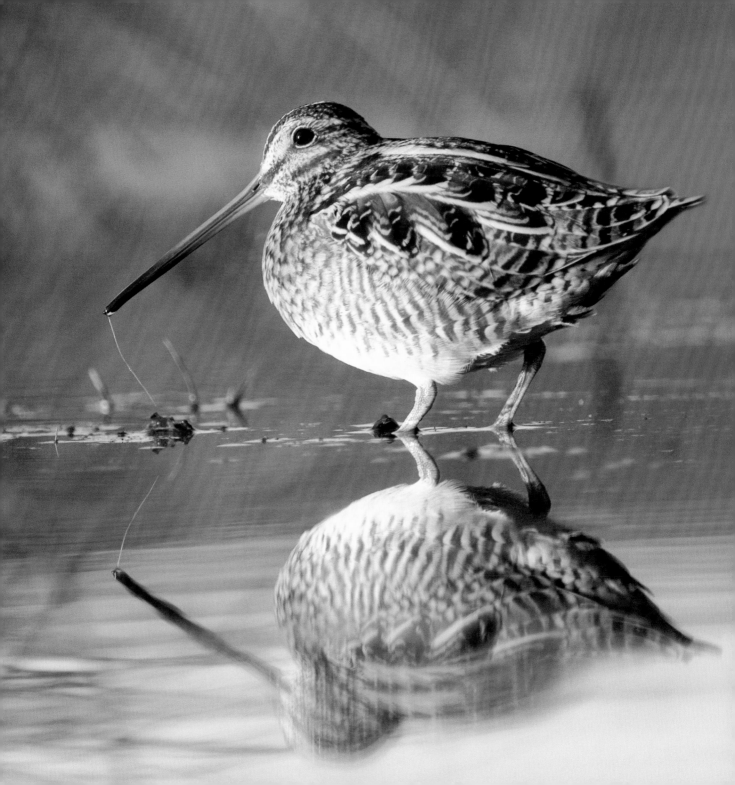

the water to capture herring and other small fish near the surface.

Terns generally haven't fared well in recent decades in the Bay of Fundy (and elsewhere on the eastern side of the continent). They were slaughtered for the millinery (hat) trade in the late 1800s and only the enactment of the Canada–U.S. Migratory Bird Convention in 1916 saved the species from possible extinction in North America. Despite more recent threats to their survival, such as the chemical DDT in the 1950s and 1960s and a burgeoning gull population competing for limited nesting sites (a "tern warden" was once stationed on Peter's Island during the nesting season to ward off herring gulls), the terns on Peter's Island appear to be holding their own, at least for now.

All told, over 100 bird species, both of the ocean and of the land, residents and migrants alike, depend on the Bay of Fundy's mud flats, salt marshes, marine waters, and watershed forests for their survival. Of all the higher animals that count on the health of the bay's ecosystems, none are more noticeably present or *absent* than the birds.

Facing page: This semi-palmated plover, the most abundant plover during fall migration, rests on one leg as the Sun sets on another day of feeding on the vast mud flats of the upper Bay of Fundy.

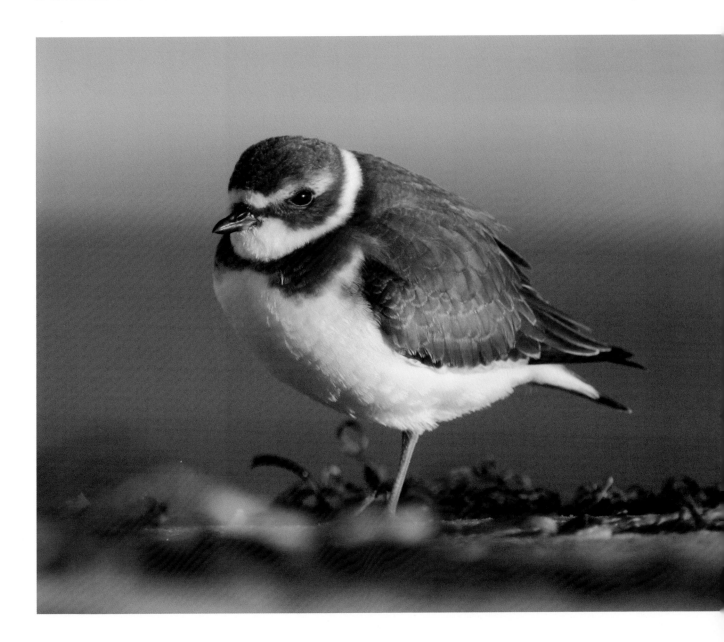

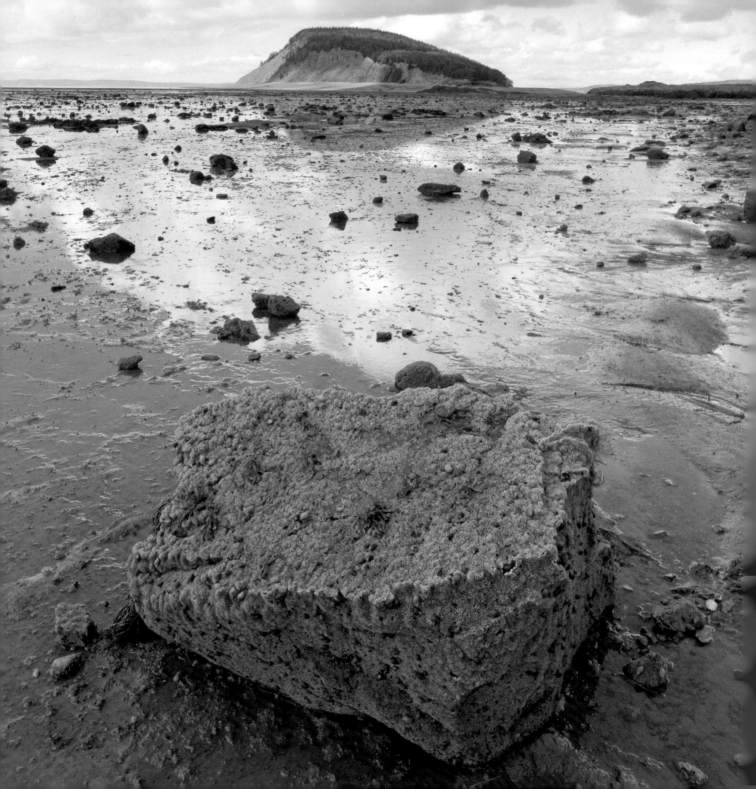

CHAPTER 5

Where the Land Meets the Bay:
A Story of the Earth, the Moon, and Time

MORE THAN 200 MILLION YEARS AGO, BEFORE THE existence of the Atlantic Ocean, before North and South America and Africa, molten rock from deep within the planet welled up to create enormous heat just beneath the surface of the ancient continent known as Pangaea. The incredible pressure resulting from this caused the Earth's crust to get thinner, then tear. These tears became rift valleys of great volcanic activity, similar to Africa's Great Rift Valley today. Fundy Basin, precursor to the bay, was one such place. A huge amount of lava flowed to the Earth's surface here and cooled. That solidified lava is the basalt that now underlies the bay. It also forms its coast from Cape Split in the Minas Basin, westward to Brier Island and across to Grand Manan Island where basalt towers 120

Facing page: A large chunk of barnacle-encrusted basalt sits in the middle of an enormous mud flat on the Minas Basin in Nova Scotia.

metres above the sea in the highest cliffs on the eastern seaboard of the continent.

In contrast to the hard, durable basalt so characteristic of the lower bay, much of the upper bay, specifically Nova Scotia's Minas Basin and New Brunswick's Chignecto Bay, is characterized by more-easily-eroded red sandstone. Deposited hundreds of millions of years ago as sediment at the bottoms of lakes and rivers when this part of the Earth had a tropical climate, the soft, sedimentary rock has been naturally sculpted into wild cliffs, sea arches, and a generally spectacular coastline.

In places, the eroding sandstone has revealed important fossils that tell the story of life in the distant past. At Joggins on Chignecto Bay, cliffs of Carboniferous Period rock have yielded a diverse trove of fossils, including some of the earliest reptiles known. A candidate UNESCO World Heritage Site, Joggins attracts scientists from around the world. Forty kilometres south of Joggins, a rich assemblage of fossilized crocodiles, sharks, fish, lizards, and some of

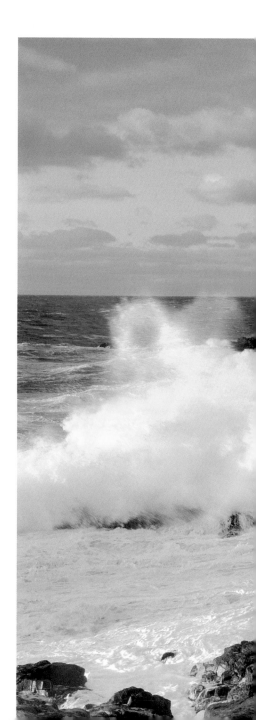

Western Point, Brier Island (the nearest point of land to Gull Rock) is located at the entrance to the Bay of Fundy where it meets the Atlantic. Here, where the boundary between the bay and the open sea is blurred, the Fundy displays its oceanic character as an autumn storm whips the water into large waves.

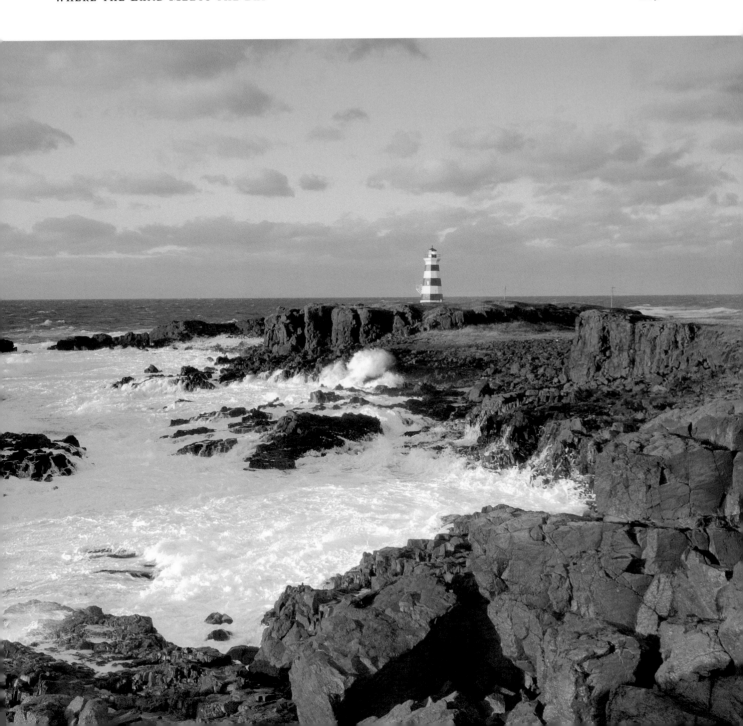

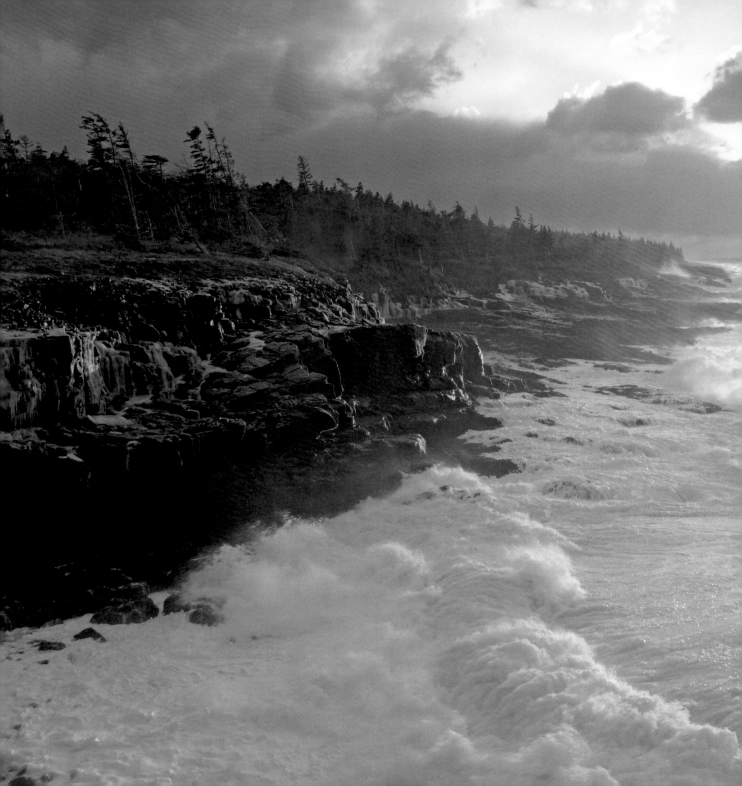

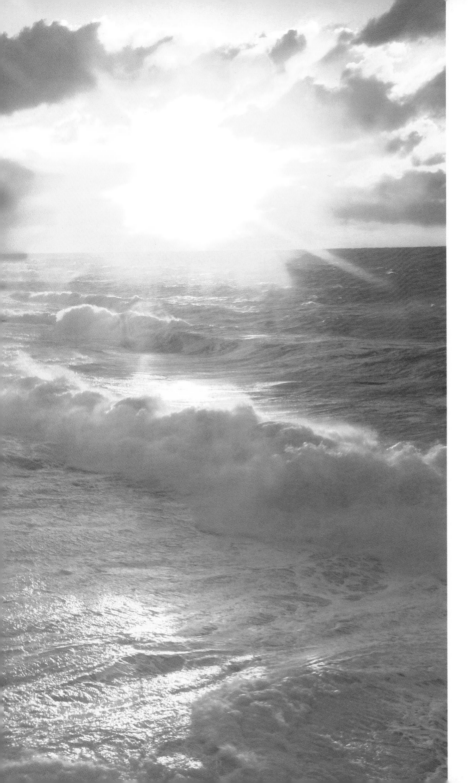

A winter windstorm along Nova Scotia's lower Bay of Fundy shore brings enormous waves crashing into the basalt coast.

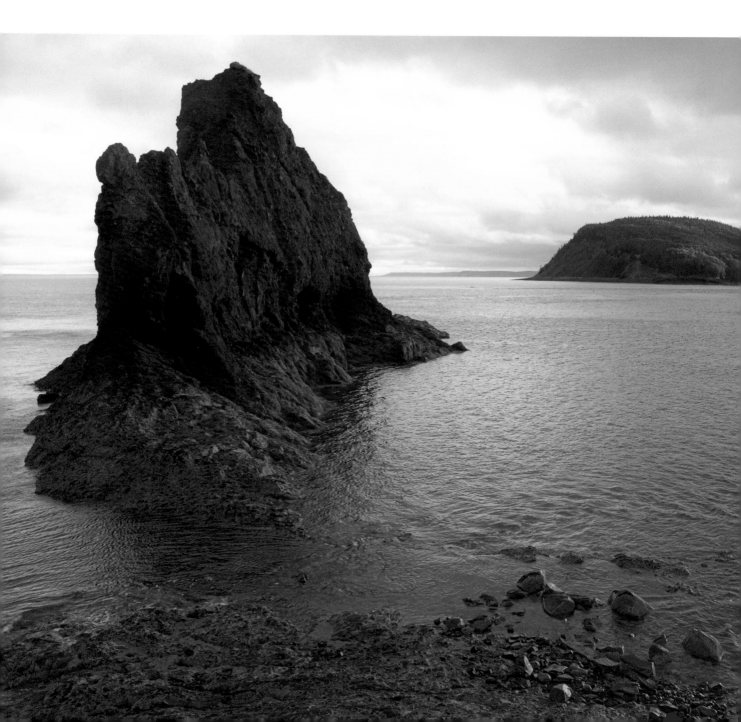

the oldest dinosaurs ever found in Canada were discovered at Wasson Bluff on Minas Basin in 1984. Paleontologists from around the world continue to flock to a variety of sites around the upper Bay of Fundy, which has a well-deserved reputation in the study of early life on Earth.

At first light and in the evening, the shoreline of the upper Bay of Fundy glows a deep primordial red that's reminiscent of the colour found in the "red rock" deserts of the American southwest. Some of the formations are truly spectacular. Near Hopewell Cape in New Brunswick, 300 million-year-old rock has been eroded by the tide into the Hopewell Rocks. With their verdant topping of trees, this unusual group of sea stacks has become known as the "flowerpots."

I realize just how strange the Bay of Fundy can be as I stroll on the sea floor among 12-metre-tall natural flowerpots that will soon be an archipelago of tiny islands surrounded by deep tidal water.

Some of the highest tides in the Fundy occur at Hopewell Cape. Just six hours after walking around the

This basalt sea stack at Old Wives Point, Minas Basin, is inundated by the sea at high tide.

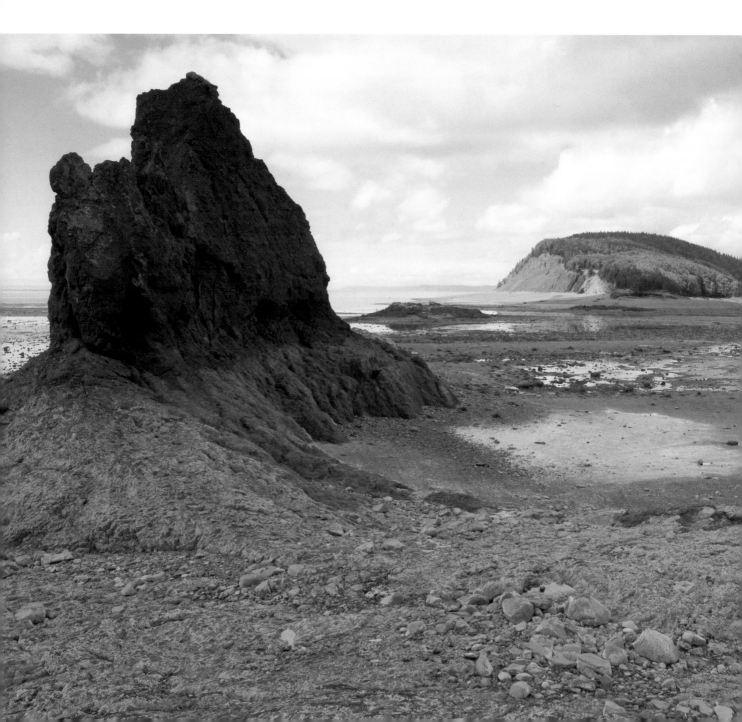

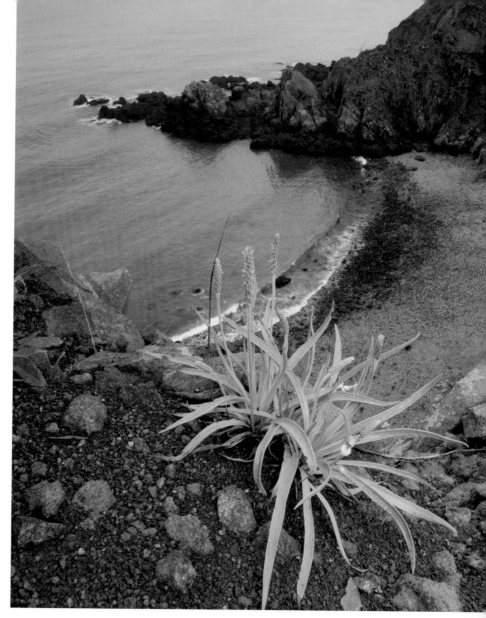

Left: The same sea stack at Old Wives Point at low tide. Moose Island, in the distance, can be reached by walking.

Above: This plant clings tenaciously to the very edge of a 60-metre basalt cliff on the southwest coast of Grand Manan Island.

Facing page: The columnar nature of basalt, apparent throughout the bay, but especially on the islands near its mouth, is evidence of great volcanic activity.

Below: The layers of the ages are apparent in Five Islands on the Minas Basin where dark grey, newer basalt overlies older sandstone. Important fossil deposits in similar sandstone deposits nearby reflect much of the history of life in the Bay of Fundy.

flowerpot rocks at low tide, I'm paddling among them in a sea kayak. Nearly 14 metres (about the height of a five-storey building) directly below are my footprints in the mud. A few moments earlier, the brown, silt-laden water was churning in the powerful incoming current. In another few minutes it will begin to flow in the opposite direction, at first with just a hint of movement, until finally becoming a torrent. An immense volume of water will drain out of the Bay of Fundy back into the Gulf of Maine over 200 kilometres away. Each hour over 8 cubic *kilometres* of

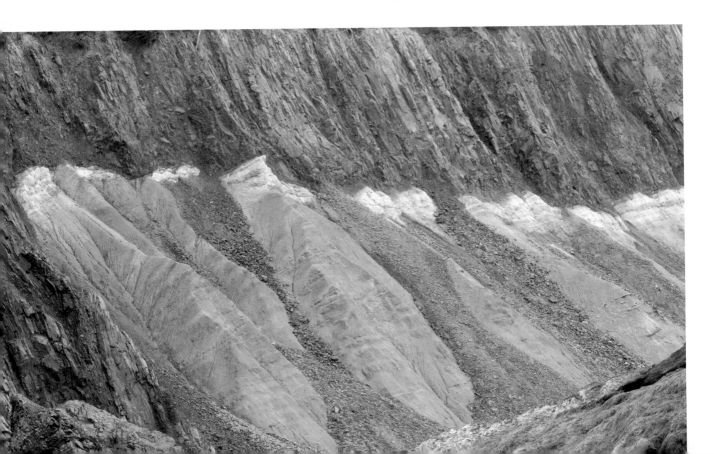

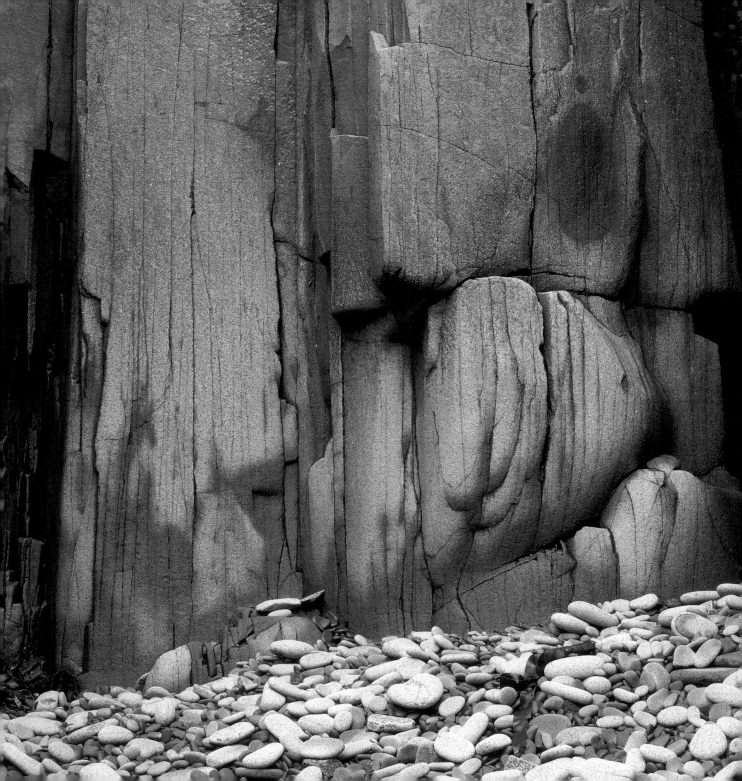

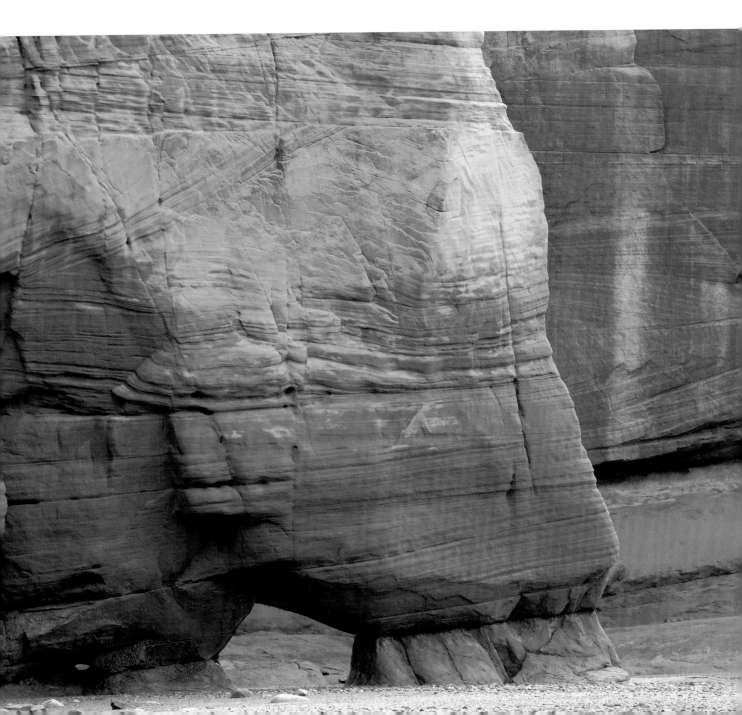

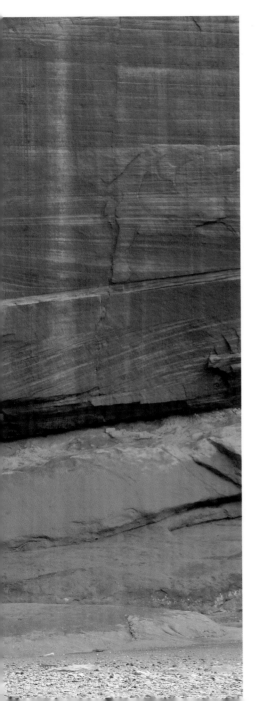

water move in or out as the tide floods or ebbs.

All coastlines on the planet have tides that are caused by the gravitational pull of the Moon and, to a much lesser extent, the Sun. High tides are actually formed by two bulges of water, one on each side of the Earth. As the Moon's gravity tugs the hardest on the side of the Earth facing it, it lifts the water into a bulge and forms the high tide. The Earth itself, behind the bulge, is a little farther away from the Moon and feels less of the pull while the water on the opposite side of the Earth, farthest away of all, is subject to the least amount of force and gets "left behind" as another bulge (a second high tide) halfway around the planet, or twelve hours of rotation away. To create the high tides, all that extra water must be drawn from somewhere. It comes from the tidal valleys, the low tide areas between the bulges that are at right angles to the Earth/Moon axis. So, in effect, the tide doesn't really come in or go out, but the Earth rotates into, then out of the gravity induced bulge. Tide times are fifty-two minutes

Sandstone is a sedimentary rock, which means that it has been deposited over time by water or wind. This is seen here in the many layers that make up this cliff and formation in the upper bay. In this case the layers were laid down over 200 million years ago on the bottoms of ephemeral lakes.

later every twenty-four hours (or thirteen minutes later every successive high and low tide since there are two of each per day). This phenomenon is due to the Moon's changing position relative to the Earth as it travels on its twenty-eight-day journey around us. During the twenty-four hours it takes our planet to spin once on its axis, the Moon advances one-twenty-eighth of the way around it, accounting for tides that are fifty-two minutes later every day (one-twenty-eighth of the 1,440 minutes that make up a day).

The positions of the Moon and Sun also have an effect on the tides. Twice every month, when they are lined up with the Earth, their combined gravitational pull results in very high tides (known as spring tides). Then, a week later, when the Sun and Moon are at right angles to one another, the Sun's minor pull cancels out the Moon's somewhat, resulting in weak tides twice monthly (neap tides).

No place on Earth is affected as dramatically by all of these forces as the Bay of Fundy. The lunar pull is the same here as anywhere else on the planet, however, owing to a chance coming together of two additional factors, its effect

Often shrouded in fog, the basalt cliffs along the west coast of Grand Manan Island are some of the highest found on the eastern seaboard of North America. The columnar structure of the cliffs is apparent.

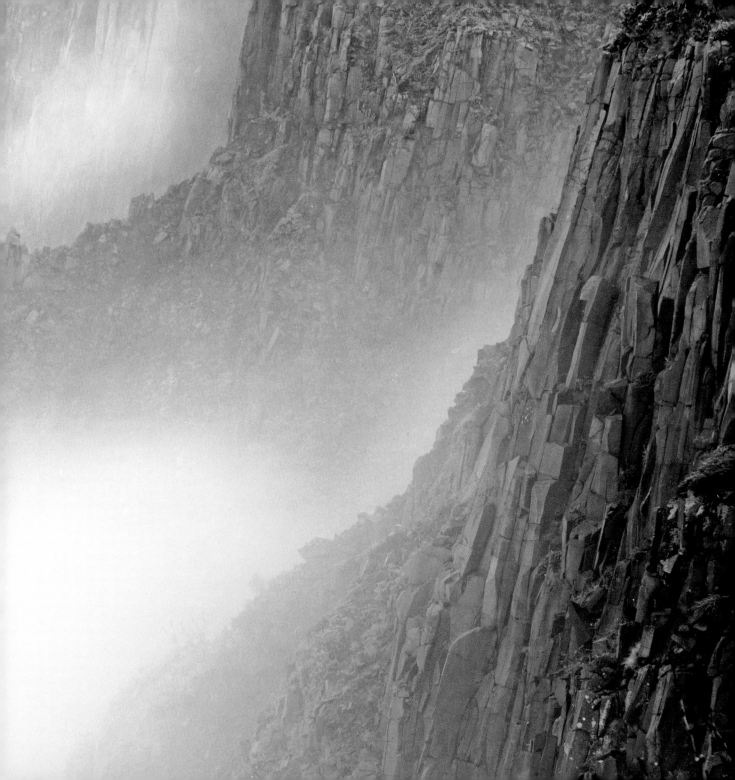

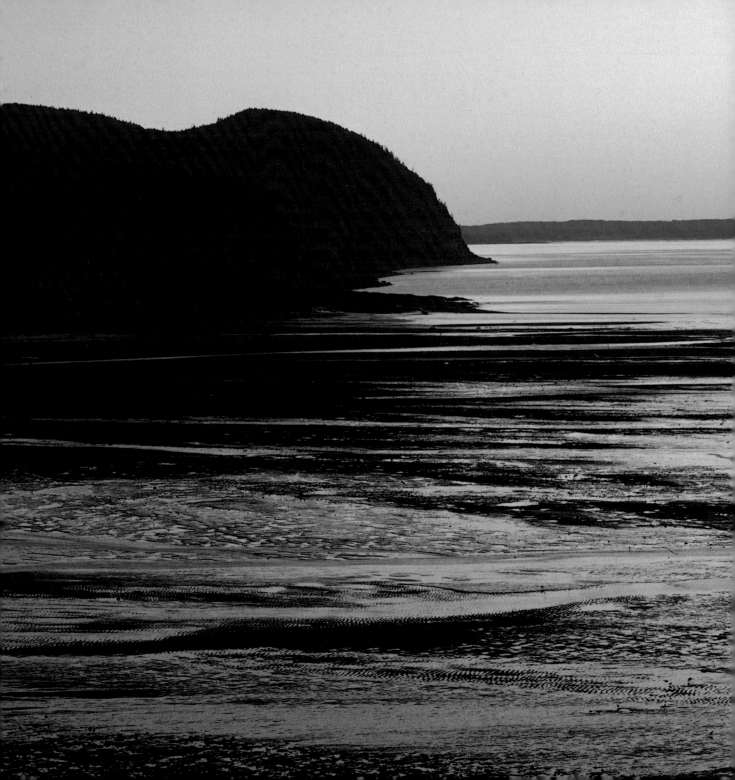

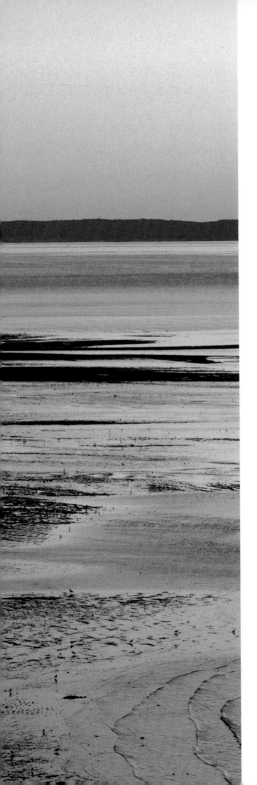

can be fifteen times as great as it is on the average seacoast.

It's apparent on a map that the bay is shaped somewhat like a funnel. This configuration squeezes slow-moving, spread-out water into a fast-moving, compact stream. This principle is at play as the massive amount of water from the deeper and wider Gulf of Maine is forced into the progressively narrower, shallower Bay of Fundy. The water "piles up" more and more on its way up the bay, increasing in height about a metre for every 30–40 kilometres it travels, finally reaching a zenith in the upper reaches of Nova Scotia's Minas Basin and New Brunswick's Chignecto Bay.

As important as its shape is for making big tides, this alone is not enough to account for Fundy's world-record amplitudes. Other bays and inlets around the world appear to be just the right shape as well, but none of them generate tides in the same league. Something additional is at work in the Bay of Fundy.

Each body of water, regardless of its size, has a natural oscillation that depends on its overall shape, depth, length, and width. As an illustration, picture waves bouncing back and forth in a bathtub in a rhythmic rocking motion. The water first sloshes up one end of the tub, then rolls back up the opposite end, like an aqueous pendulum.

Low tide in the twilight at Funday National Park, New Brunswick.

Though it might take only a few seconds for this to happen in a bathtub, it takes about thirteen hours for the water to rhythmically rock from the mouth of the bay up to its head and back again. This is Fundy's period of resonance or its seiche. By a beautiful quirk of nature, it happens that the rising ocean floods into the bay every thirteen hours also. As it does, it synchronizes with the natural rhythmic movement of the bay's waters to create tides of world renown.

Some 70 kilometres south of Hopewell Cape is Cape Split in the Minas Channel, the site of the most spectacular tidal flow anywhere on Earth. A long hike is the price of admission one pays to view this natural wonder. After slogging in the rain on the hilly woodland trail for two hours, I finally emerge onto a small grassy meadow. This is the very end of Nova Scotia's North Mountain, the 250-kilometre-long ridge of basalt that forms the southern boundary of the Bay of Fundy and Minas Channel. I'm surrounded on three sides by dizzying 70-metre cliffs. The bay reaches westward to the Atlantic before me, the horizon broken only by the distant Isle Haute, an obdurate rampart of basalt that is an important nesting site for common eiders and black guillemots. An awe-inspiring torrent of

water rips past the detached massif of Cape Split's terminus, jutting like a giant sickle into the bay below me. Billions of tonnes of water rush past the point at an astonishing velocity of 8 knots, creating a deep, seismic roar fittingly known as "the voice of the Moon."

The rushing tides of Fundy are just as impressive underwater as above, as this kelp forest lying flat in the current illustrates.

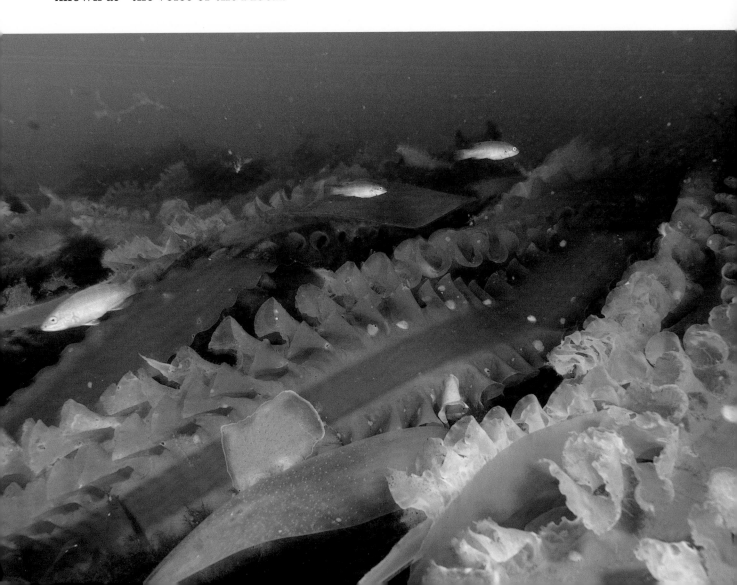

CHAPTER 6

A Ribbon of Green:
Marshes of Fundy

I'M SITTING IN A SMALL PHOTO BLIND ON THE Queen Anne marsh beside Annapolis Basin, an estuary on the lower Bay of Fundy. Just a kilometre away is Port Royal habitation, the site of the first permanent European settlement in Canada, founded by Samuel de Champlain in 1604. Hundreds of hectares of salt marsh, hayfields, "old field" habitat (land long left fallow, now turning wild),

This salt marsh in Annapolis Basin is showing the brown and gold colours characteristic of fall. At this time of year the dying spartina grass begins to return to the Bay of Fundy in the form of detritus, which feeds the bacteria. This bacteria, in turn, sustain ecologically important organisms such as zooplankton, marine worms, and mud shrimp.

141

and freshwater marsh create a patchwork of habitats here. There's a chill in the early morning air, and a slight mist wafts over the dewy vegetation. In the periwinkle dawn is a gibbous Moon, its visage soon to be extinguished by the Sun. The object of my interest approaches on deeply-beating wings. A short-eared owl flies close to the tips of the tallest grass, its large yellow eyes scanning the ground as it hunts rodents in the growing light. Its floppy wings take it a few hundred metres away to the edge of the mud flat, then back again as it searches for breakfast. In a happy coincidence,

An American bittern responds to danger by striking a "hiding" pose in an attempt to blend with the surrounding dikeland marsh.

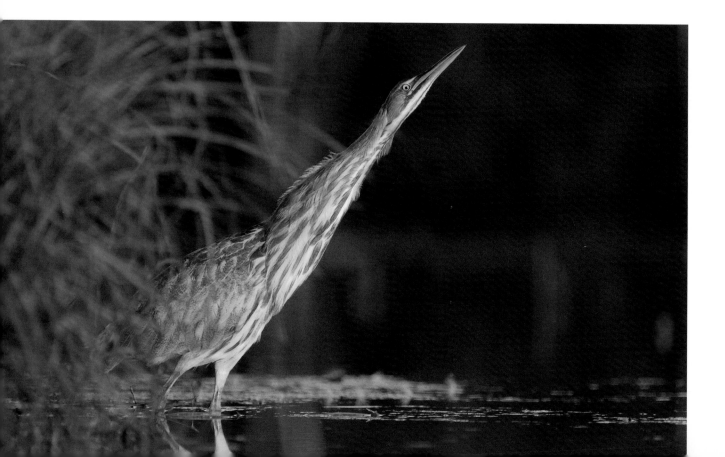

the owl moves close enough to where the Moon sits in the sky for me to photograph them together. After a few minutes, unsuccessful in its hunt, the owl drifts away over the dike into a large hay meadow.

There is more to the Bay of Fundy ecosystem than the saltwater realm of fish and whales, or the expansive mud flats that are so vital to throngs of migrating shorebirds. Over 100 square kilometres of verdant salt marsh rims the bay. These "ribbons of green" are found largely in its many estuaries. Although only a fraction of their original

Deer are common on salt marshes and adjacent dikelands during summer. The dike and bay are visible in the background.

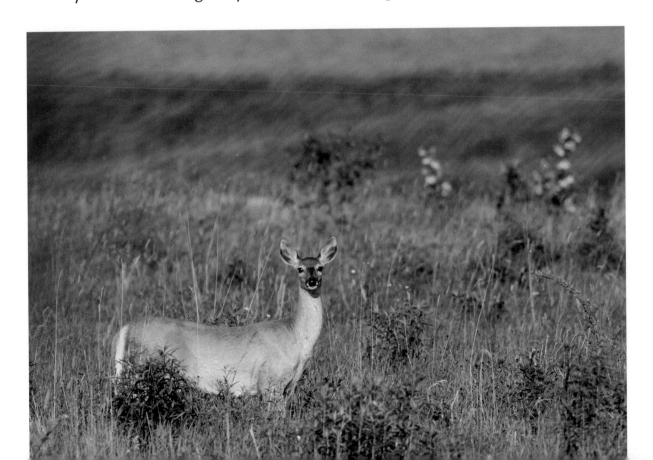

extent remains (the rest has been sequestered behind hundreds of kilometres of dikes, many of them originally built by the early Acadians), salt marshes continue to play a vital role in the health of the Bay of Fundy's ecosystem.

Some areas around the lower bay boast considerable salt marshes; for example, Annapolis Basin and St. Mary's Bay in Nova Scotia, and the Musquash River estuary in southwestern New Brunswick. However, the largest ones

Facing page: A black darner dragonfly rests on a dead cattail stalk in a coastal freshwater marsh on St. Mary's Bay, an arm of the lower Bay of Fundy.

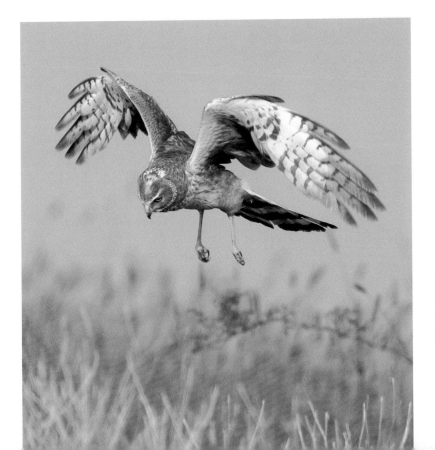

This page: A northern herrier, the most commonly observed bird of prey on the salt marshes and freshwater marshes around the bay, hovers over potential prey.

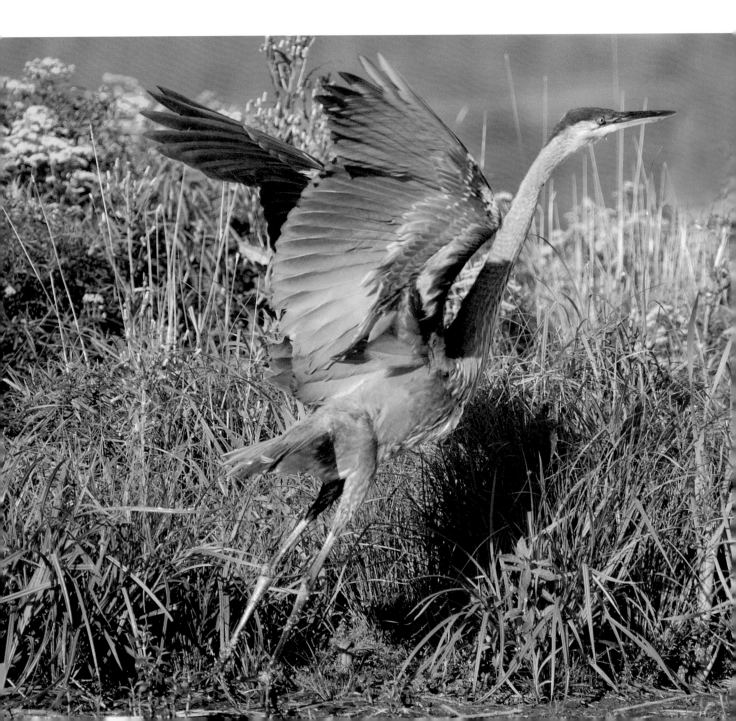

are found at the head of the bay, in Minas and Cumberland basins and Chignecto and Shepody bays. Here, where the Fundy tide reaches its peak, is one of the largest complexes of this habitat on the eastern seaboard of North America.

The dominant species here are two kinds of spartina grasses (also known as cord grass), hardy plants that tolerate salt. Each type of grass has its special habitat based on elevation and exposure to salt water. *Spartina alterniflora* grows in the saltiest lower part of the marsh and *Spartina patens* in the higher parts. Together, they form the foundation of an ecosystem that is at once terrestrial and marine. Part solid earth, part water, the marsh is dependent on the sea and the Sun in equal measure. On the spring flood tides when the water is at its highest and covers most of the grass, the ocean delivers essential fertilizer in the form of sediment-borne minerals that get left behind as the tide recedes. The Sun provides its life-giving light, essential to photosynthesis. A rapid growth spurt ensues, bulking up the amount of biomass throughout the summer. In the fall the salt marshes, in turn, give back to the bay as the decaying grass gets washed out on the falling tide. This rotting plant matter, known as detritus, is consumed by the bacteria which are the foundation of a food web that sustains invertebrates such as zooplankton,

Facing page: A great blue heron takes off from the edge of a brackish marsh in the Annapolis Basin estuary.

Below: This savannah sparrow has found a beautiful perch on some blue flag irises in a small coastal freshwater marsh near the landward edge of a salt marsh.

Right: Though not as common as spartina grass, reed grass is found in Chignecto Bay and other parts of the Bay of Fundy.

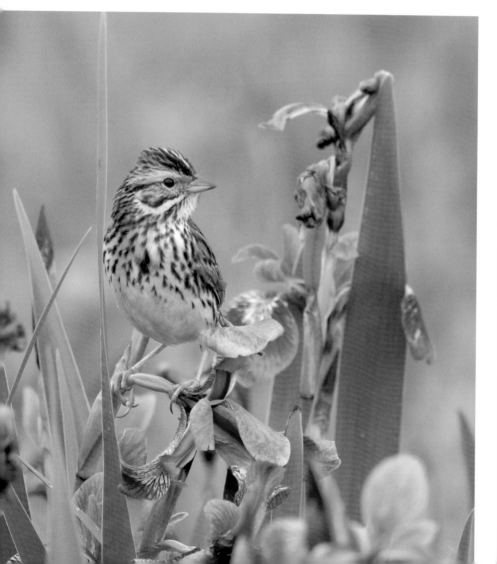

Facing page: A sora perches on a cattail plant in a coastal freshwater marsh in Cumberland Basin of the upper Bay of Fundy.

Below: A short-eared owl, the most common owl species observed about the salt marshes of the Bay of Fundy, skims an old dikeland hayfield for rodents.

marine worms, mud shrimp, and other species. These, in turn, feed higher animals such as fish, birds, seals, and whales. This gift of the grass is a vital strand in the bay's overall food web.

Salt marshes provide habitat for a number of species. Sea lavender, milkwort, and reed grass are just a few of the salt-resistant plants that grow on the higher parts of the marsh, while rockweed and green algae grow at the lowest level. Eelgrass is found in a few isolated areas below the low-tide mark. Hordes of sandpipers find food and refuge

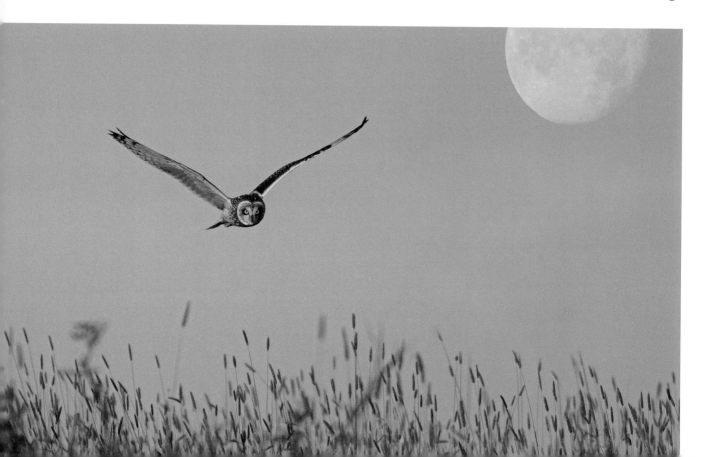

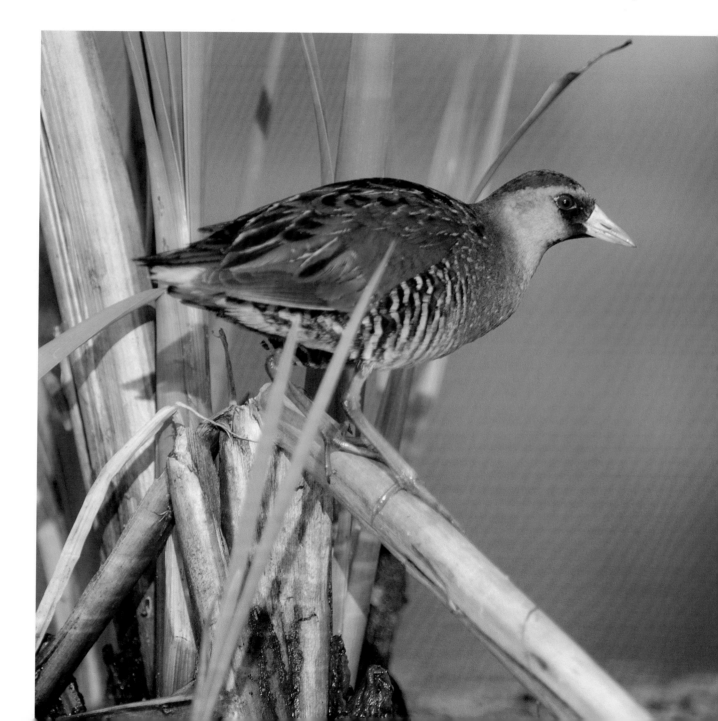

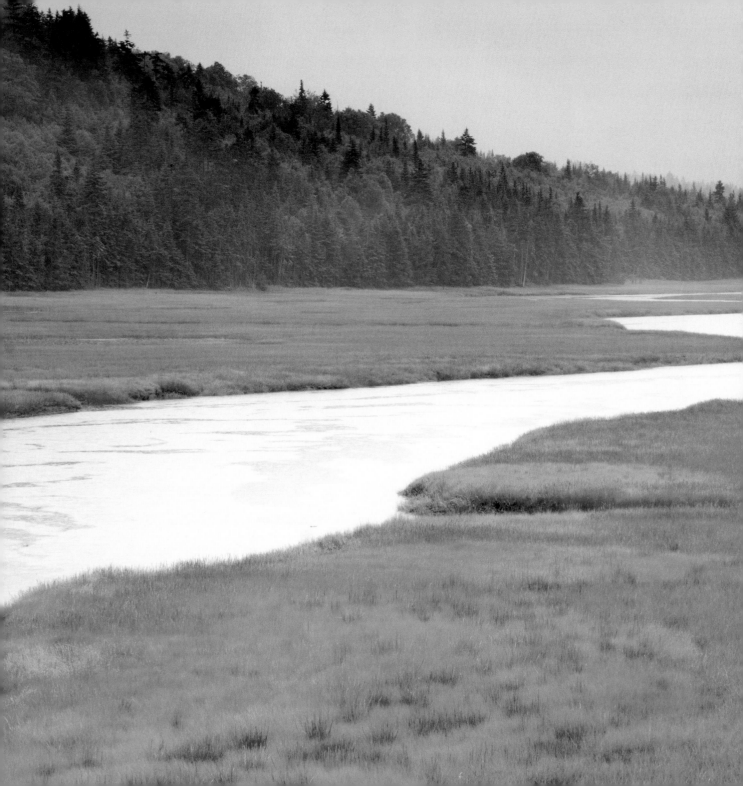

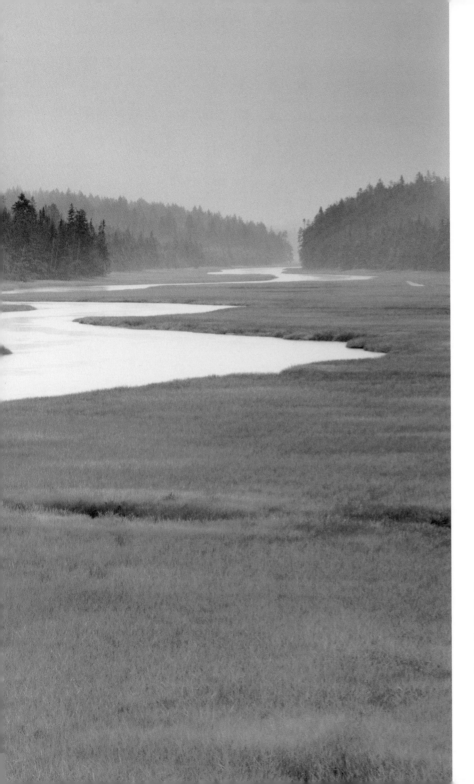

A typical natural salt marsh and estuary, such as this one on the Bay of Fundy in southeastern New Brunswick, is characterized by a verdant growth of spartina grass and an unfettered passage of water.

in the extensive salt marshes adjacent to the mud flats that are their primary feeding grounds. In salt marshes and associated coastal freshwater marshes, savannah and sharp-tailed sparrows, tree swallows, and common yellow-throats abound. The great blue heron is as likely to be seen at the seaward edge of the mud flats as it is hunting in a creek or in a panne, which is a permanent or semi-permanent small pond created in a poorly drained area of the marsh. A top salt marsh predator, the great blue heron preys on a variety of animals, including dragonflies, green crabs,

Facing page: The divide between less salt-tolerant salt meadow cordgrass on the flat area to the left and the salt-loving smooth cordgrass sloping down the creek side on the right is apparent on this Chignecto Bay salt marsh in New Brunswick.

Below: A tree swallow zooms over a Bay of Fundy salt marsh as it hunts for flying insects to take back to its nestlings.

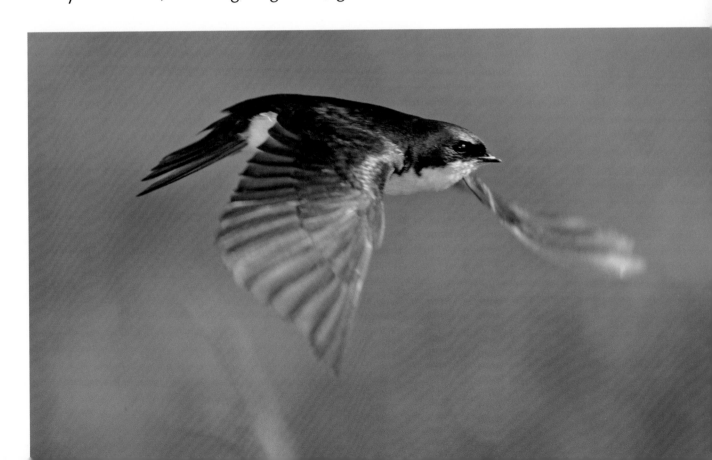

156

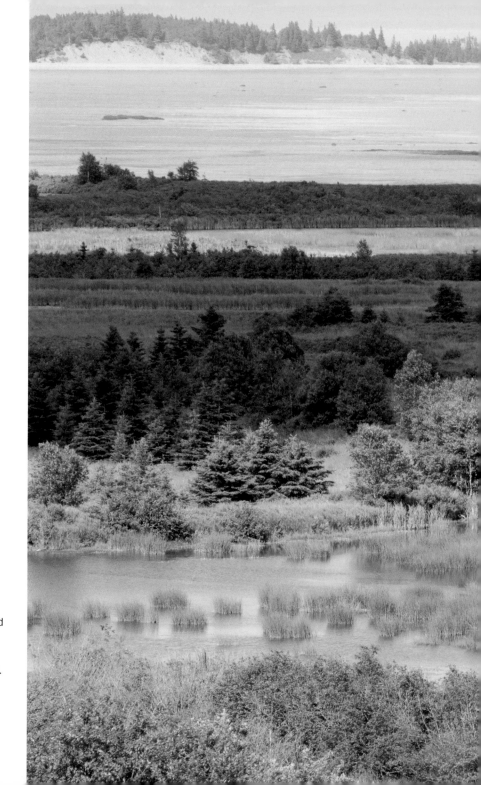

Whether of natural origin or created behind a dike, freshwater marshes, such as this one on Shepody Bay, are often located adjacent to the Bay of Fundy salt marshes.

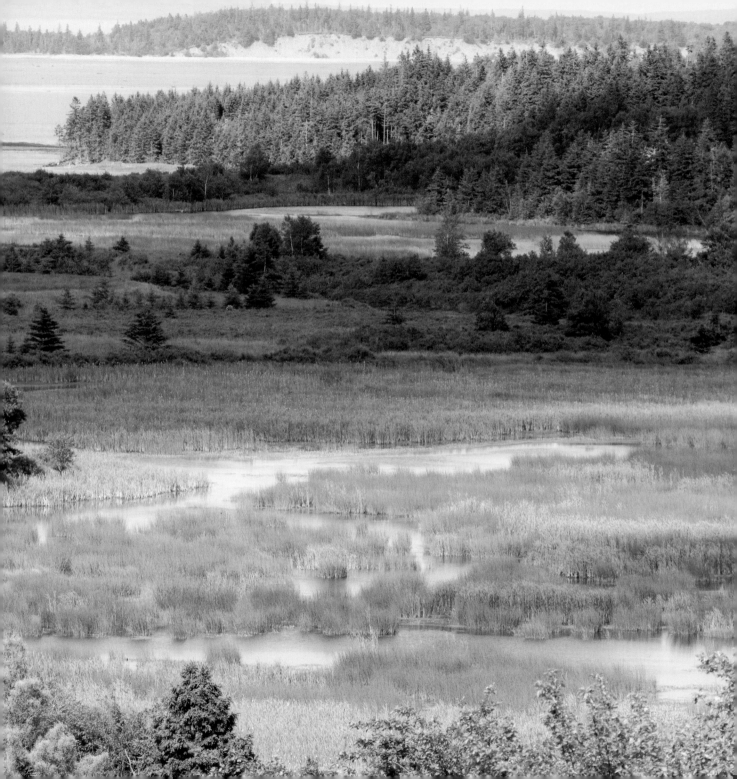

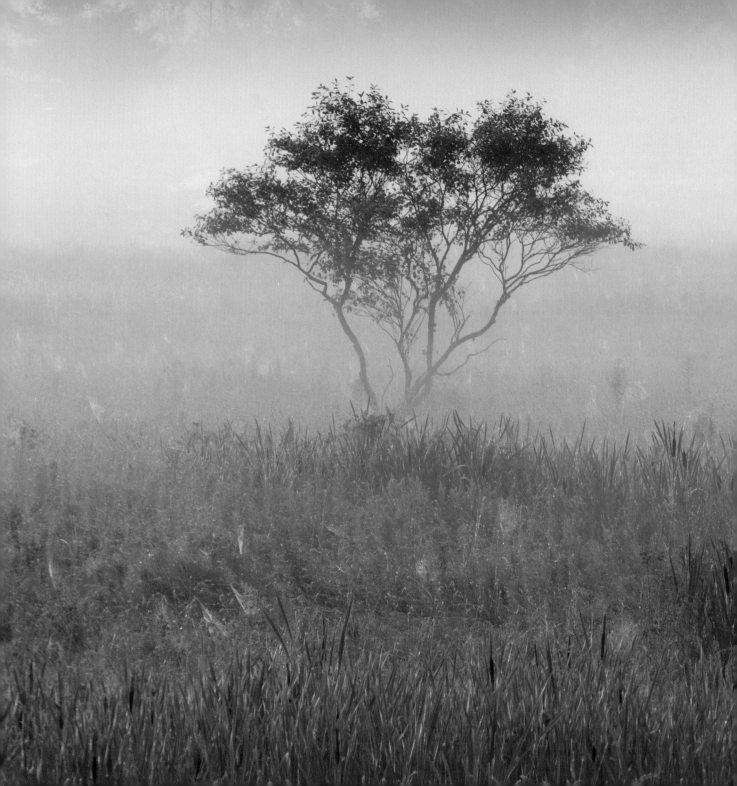

and fish like gaspereau, American eels, and the occasional juvenile flounder. Clams, mussels, several snail species, and burrowing sea anemones are abundant in the intertidal zone. In summer, raccoons will visit to feed on clams and crabs, and mink raise young if a suitable nesting den, such as a washed-up hollow log, can be found.

Extensive dike building, beginning with the Acadians in the 1700s, converted much of the salt marsh ecosystem around the bay into some 20,000 hectares of farmland. Today, much of this land is important wildlife habitat in its own right for a variety of birds, mammals, and insects. Because they have been fallow for years, many dikelands have been transformed into wild fields of grasses and thickets, crossed by creeks and dotted with small freshwater marshes. As the habitat diversified in this way, so did its inhabitants. In summer, white-tailed deer browse on vegetation while enjoying a cooling breeze that keeps biting insects at bay. American bitterns, pied-billed grebe, various species of ducks, and sora rails inhabit the small freshwater ponds and marshes that formed after the sea was shut out by the dikes. Bobolinks find a refuge for their nests in the

Protected behind hundreds of kilometres of dikes, many of Fundy's dikelands have become wild habitats of grass, shrubs, thickets and freshwater marsh.

long grass. Abundant populations of meadow voles, mice, and shrews attract red foxes and coyotes. Spectacular birds of prey, such as short-eared owls and northern harriers, are as at home on the dikelands as they are hunting on the salt marsh.

As I prepare to leave the cover of my photo blind after the departure of the owl, a female northern harrier flies by just metres above the ground. The similarity of its hunting method to the short-eared owl's is obvious, though the harrier has a more direct flight. The chance of it returning is slim, but I wait a few minutes anyway, hoping it might come within photo range. In the second lucky strike of the day, the harrier comes back across the marsh and flies close, directly in front of me, proving Heraclitus's maxim: "If you do not expect the unexpected, you will not find it...."

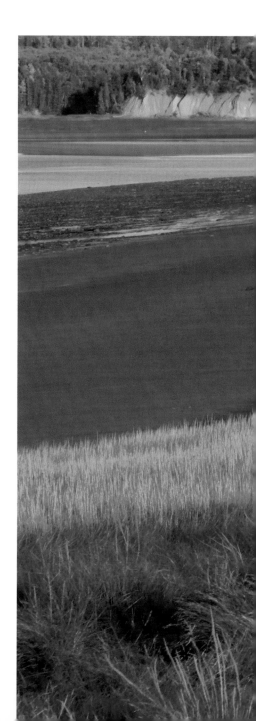

A salt marsh near the mouth of the Shubenacadie River in the Upper Bay of Fundy's Cobequid Bay.

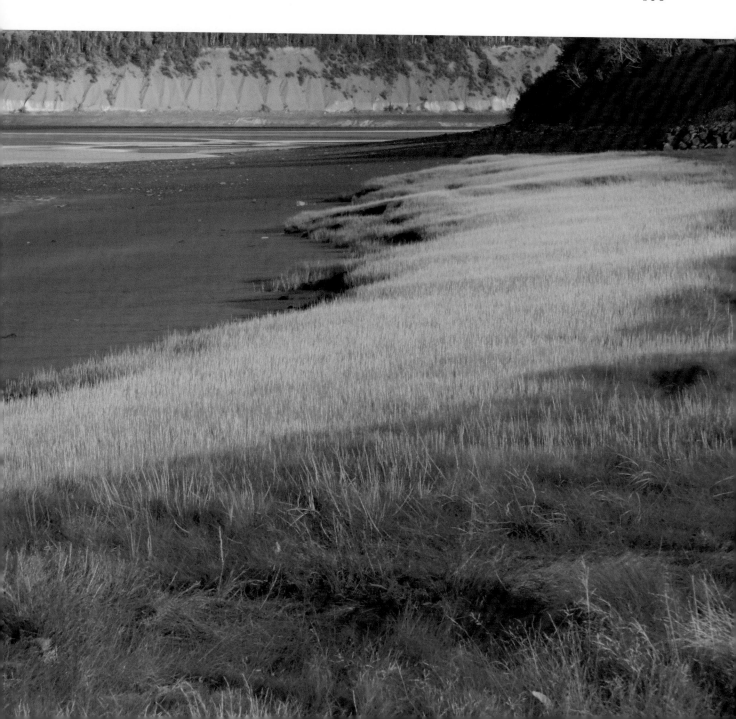

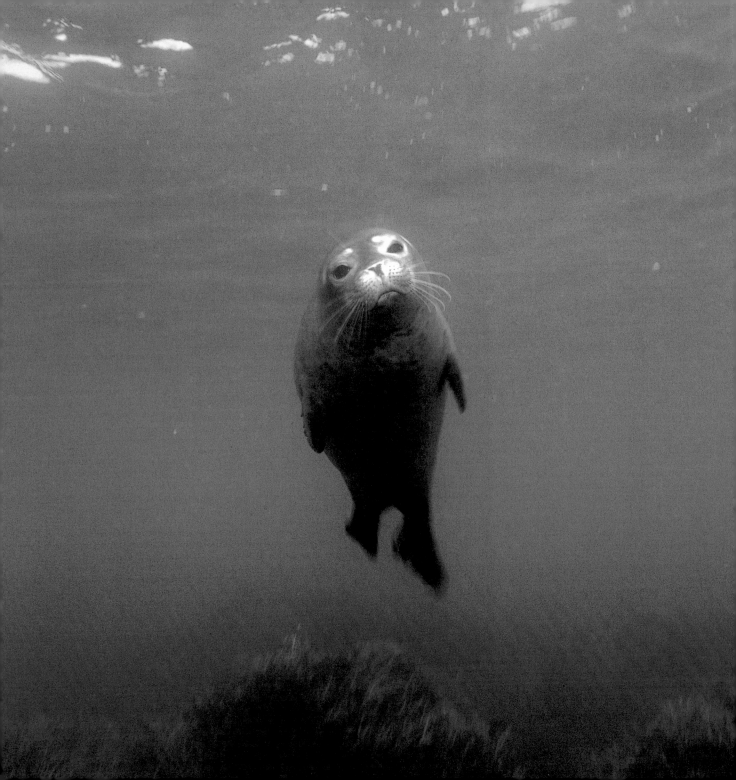

Epilogue

THOSE BRIEF MOMENTS OF SWIMMING WITH A RIGHT whale are deeply etched in my memory. We came eye to eye with one of the last individuals of a magnificent species, a privilege few enjoy. When that whale disappeared into the Bay of Fundy, I knew that I would likely never again encounter one in this way. North Atlantic right whales are so rare that within decades they may be extinct.

With the current population of only 300 or so animals, genetic diversity is low, so there is little resilience to deal with natural challenges such as disease. An even greater threat, of course, is the burgeoning human activity in the bay. With so few individuals, every right whale that dies by being struck by a passing ship or by getting tangled in fishing gear represents a significant reduction in the

Facing page: Intelligent and inquisitive, harbour seals are one of the top predators in the bay. They, like all other species that live in the Fundy, most be accorded a healthy ecosystem in which to live their lives.

likelihood of the continued evolution of the species.

Right whales are symbolic of the challenges that face the Bay of Fundy. Humans' exploitation of the bay continues apace despite diminishing returns. The commercial fishery must work harder and harder for an ever decreasing catch of lobsters, scallops, and groundfish. This ecosystem can take only so much before it passes the point of no return. We have only to look to the disaster in the Newfoundland cod fishery for a tragic example close to home. Aquaculture, especially of genetically manipulated Atlantic salmon, is a rapidly growing multimillion-dollar industry in the Bay of Fundy. It is not the panacea it was promised to be and contributes a large amount of pollution to the surrounding ecosystem, as well as posing the threat of disease to already dimished wild Atlantic salmon stocks. And aggressive alien species, such as the Japanese shore crab, threaten to disrupt whatever natural environment they enter. Proposed basalt mega-quarries may destroy inshore fisheries for species such as lobster and sea urchins, and ruin the quality of life of local human communities. Another potential threat is the resurrection of the Bay of Fundy tidal hydroelectric power idea. Heavily promoted in the late 1970s and early 1980s, this concept was ultimately dropped because it was seen to be too potentially damaging to coastal ecosystems in the bay and in the Gulf of Maine. The

potential impact on every aspect of the marine ecosystem, from changing patterns of tidal flow to the effect of siltation on the mud flats of the upper Fundy, is unknown. Whether new designs and technology can minimize environmental damage while allowing society to take advantage of the prodigious power of the tides has yet to be seen. The challenges humankind presents to the Bay of Fundy are many.

The Moon creates tides that deliver the lifeblood of plankton on which everything from the North Atlantic right whale to the Fundy mud shrimp depend. The unique character of the Bay of Fundy is determined by factors that span an enormous scale, from the astronomical to the microscopic. Like intricate clockwork, each individual part is vital to the whole. Without all the elements, the eco-system will not function properly. Fortunately, the essentials that made the Bay of Fundy one of the great marine wonders of the world are still largely there. We have the responsibility to preserve the fine workings of this geological and biological masterpiece, and should think twice about the implications its loss would have for us. Nature has been doing its part over the eons to ensure that whales and shrimp and birds and fish flourish here; now it's our turn to help ensure its continuance.

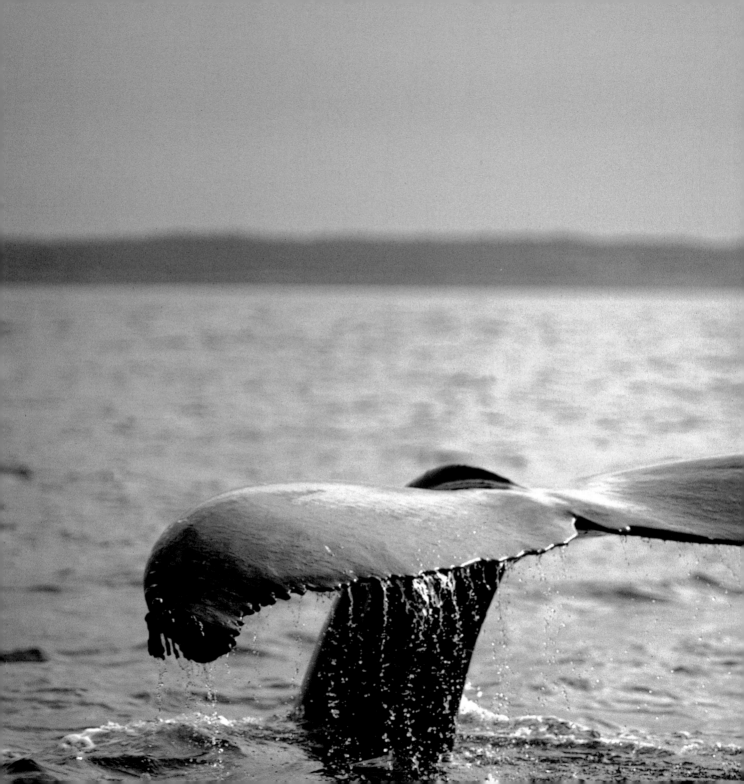

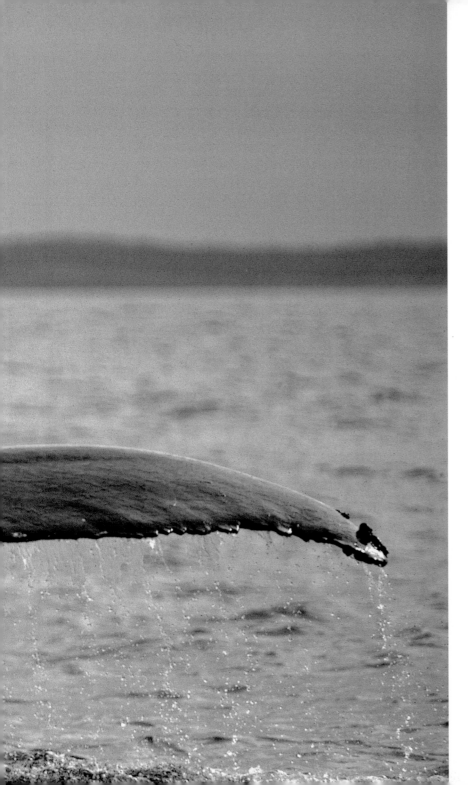

A humpback whale slides beneath the surface of the Bay of Fundy.